WARWICKSHIRE
THROUGH TIME
Jacqueline Cameron

AMBERLEY PUBLISHING

To my special friends at Café West
whose friendship I greatly value

First published 2013

Amberley Publishing
The Hill, Stroud, Gloucestershire, GL5 4EP
www.amberley-books.com

Copyright © Jacqueline Cameron, 2013

The right of Jacqueline Cameron to be identified as the
Author of this work has been asserted in accordance with
the Copyrights, Designs and Patents Act 1988.

ISBN 978 1 4456 0995 9 (print)

British Library Cataloguing in Publication Data.
A catalogue record for this book is available from the
British Library.

Typesetting by Amberley Publishing.
Printed in Great Britain.

Introduction

Born in the county town of Warwick, Warwickshire and its villages have always held a place in my heart. Although many of the villages have changed greatly in recent years, the colourful characters that were to be found in and around the shire in days past are evident today and the bond that held village life together over the years is as strong as ever. Many of the old buildings are still standing, and you only have to spend a few moments looking at them to appreciate the charisma of a bygone era.

'Shakespeare's England', the 'heart of England' and 'leafy Warwickshire' are all names traditionally given to the county, and tourists travel from all over the world to visit and admire the delights of this lovely, historic part of the globe. It has to be said, however, that with the M1, M6 and its toll road easily accessible from the shire and the M40 actually running through the middle of it, Warwickshire is very much a part of the twenty-first century.

Warwickshire is completely landlocked on all sides – Northamptonshire and Oxfordshire lie to the south-east, Gloucestershire to the south-west, Worcestershire to the west, Staffordshire to the north-west and Leicestershire to the north-east – and thus it has no coastline to call its own.

Synonymous with the centre of England, the county has three places of interest, each claiming the title. First of all, there was the cross at Meriden, then Hill Cross on Watling Street and finally the centre of England Oak, which grew in Lillington, Royal Leamington Spa. The original oak tree was felled some years ago and a sapling planted in its place, albeit in a slightly different position. A stone monument giving details of the original oak tree stands adjacent to it.

Known as 'leafy Warwickshire', the county boasts a large variety of trees, particularly elms, many of which, sadly, were blighted with Dutch elm disease some years ago. There are also a number of redwood trees to be seen in the county, relics of the Victorian era, when the redwood became very fashionable. It is mainly thanks to the trees that the Warwickshire countryside takes on a green mantle in summertime. Many are hedgerow trees, but others are the results of landscape planting carried out around large country houses built in the eighteenth century. Sadly, a large number of these beautiful old buildings have met their demise, leaving only the old trees to mark their site, which upon reaching maturity will be felled and replaced by saplings.

The county also has a number of rivers running through it and one of the most famous is the River Avon. Entering the county as a small stream near Rugby, the source of the River Avon can actually be found in Northamptonshire. A number of tributaries join the river on its journey through Warwickshire, the River Swift draining from Leicestershire, the River Sowe near Stoneleigh, and the River Leam between Royal Leamington Spa and Warwick. Rising near Daventry, the River Leam is then joined by the River Itchen near Marton. The River Avon and its tributaries flow into the River Severn and on to the Bristol Channel. All these rivers are prone to flooding when there is heavy and prolonged rainfall.

The ancient name of Warwick is derived from a settlement of the Hwicce, the earliest reference being Waerincwican in the *Anglo Saxon Chronicle*, later recorded in the 1086 survey of Warwick.

The development of the county is closely linked with the two famous castles. The first of these is Warwick Castle, with the famous Guy's Tower and Caesar's Tower and its beautiful peacocks. I remember as a child seeing them wander around the town causing havoc – they had a special liking for parading down the main street of the town, with their plumes in full array, much to the delight of visitors and locals alike. Although there were fewer cars in those days, their love of 'showing off' in Warwick caused an awful lot of chaos! Despite this, I don't remember any 'honking' of car horns.

Five miles away is Kenilworth Castle, which became one of the casualties of the English Civil War when it was pulled down by Cromwell's supporters. English Heritage now runs the ruins as a local tourist attraction. However, these are by no means the only historic buildings of note. The mile-long High Street in Henley-in-Arden boasts buildings of every type of English architecture. The Department for Environment, Food and Rural Affairs has listed almost all of the buildings, which date from the fifteenth century onwards.

Another building of note is the Manor House in Mancetter, which lies close to Atherstone, in the north of the county. Built in 1330, extended in 1580 and partly rebuilt in 1811, it is one of the most important timber-framed buildings in the county. It is from here that Robert Glover was seized and burnt at the stake in Coventry on 22 September 1555, in the reign of 'Bloody Mary'. He died a Protestant martyr.

St Peter's church in Coleshill, which was restored in the nineteenth century, boasts the best Norman font in the county, as well as four elaborate Tudor table tombs, complete with effigies of the Digby family. The family lived in the Manor House from 1495, although at the time of the Gunpowder Plot Sir Everard Digby was executed for taking part.

Moving round the county, we see the Radway Tower on the Edgehill, a folly built by Sanderson Miller, a wealthy eccentric who had inherited the Radway Grange from his father. Radway was sheltered at the bottom of the Edgehill. Edgehill is famous as the location of the first battle of the English Civil War, on 23 October 1642. My grandfather was born in Ratley on the Edgehill, married a Tysoe girl and they lived for many years in Radway. My two great-aunts ran a tea room on the Edgehill in the early 1920s.

No discussion of ancient buildings in Warwickshire would be complete without mentioning those associated with William Shakespeare and his family: Anne Hathaway's Cottage in Shottery, Mary Arden's House in Wilmcote and Shakespeare's birthplace in Stratford upon Avon itself. Anne Hathaway's cottage in Shottery was the home of John Hathaway, a farmer who had three daughters. Anne was the eldest, and although she was eight years older than William Shakespeare, they met and married when William was just eighteen years of age.

There is a delightful café called The Forties in Stratford upon Avon, where everything reflects the Second World War era, with menus printed on ration books, and green cups and saucers that remind me so much of my childhood and my own mother's green tea service. The waitresses wear period dresses and the customary head squares so much a feature of this time.

There are no hills of notable size in Warwickshire and the shire is divided into two areas of countryside, Arden, north-west of the Avon, and Feldon to the south-east. Although it is

known as the Forest of Arden, Arden being the Celtic word for a 'well wooded area', this part of Warwickshire was never a continuous forest.

In 1974, Warwickshire paid heavily when the controversial boundary changes resulted in the loss of two great cities, Birmingham and Coventry, although a few pages have been included focussing on the latter. Along with Solihull and Sutton Coldfield, they were to be known as the West Midlands, and a number of villages and a substantial piece of countryside that form the very roots of English history were also lost to Warwickshire. The character of the towns and villages and the beauty of its countryside, on the edge of the Cotswolds, reflect the still predominantly rural nature of so much of the county.

I have tried to give you a cross-section of the county, which, despite the boundary changes, is still a large one. Stretching from Atherstone and its historic neighbour Polesworth in the north to the borderlands adjoining Gloucestershire and Oxfordshire in the south and the extreme northern tip, which almost spills into Derbyshire, Warwickshire is about fifty miles from north to south and about thirty-six miles at its widest point. It is a lot to cover in one edition, but it has been a pleasure to compile this book.

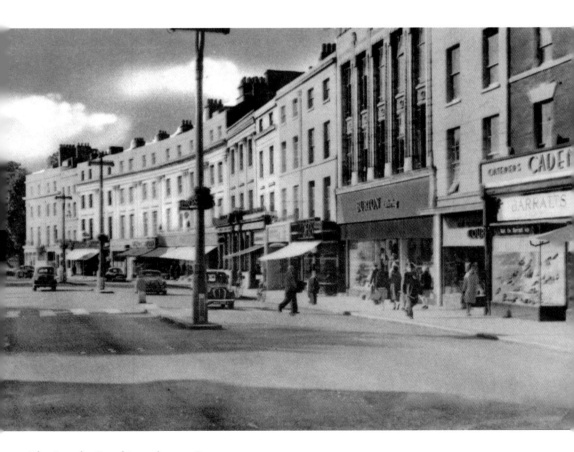

The Parade, Royal Leamington Spa

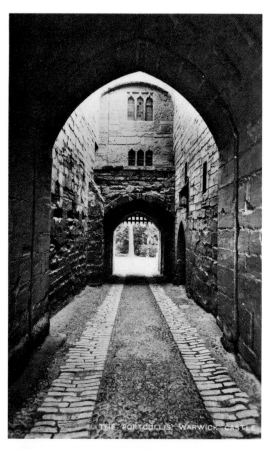

Inside Warwick Castle

Two contrasting views of the inside of Warwick Castle. The top picture shows the portcullis and the bottom view is a rare postcard showing the inside of the dungeon.

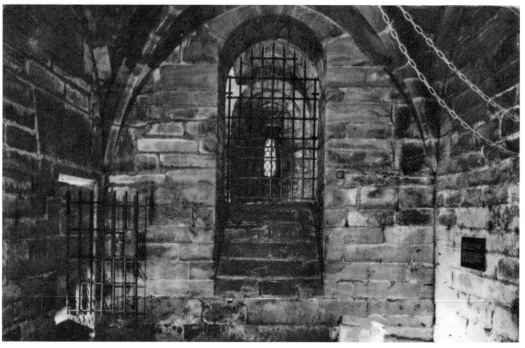

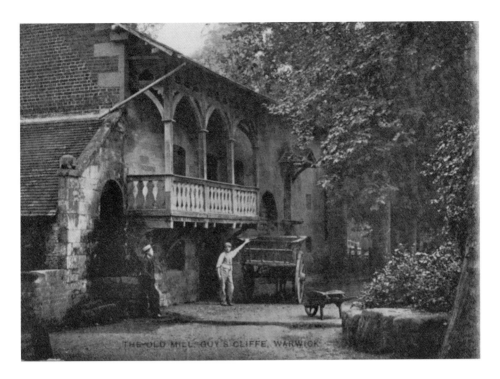

The Saxon Mill, Warwick

Since these pictures were taken, the mill has been joined to the Miller's House and turned into a successful and popular restaurant. The mill wheel has been replaced and a glass panel has been installed so that diners can watch the waters. The lovers' walk and approach, I am pleased to say, is still in situ, although it has been strengthened over the years.

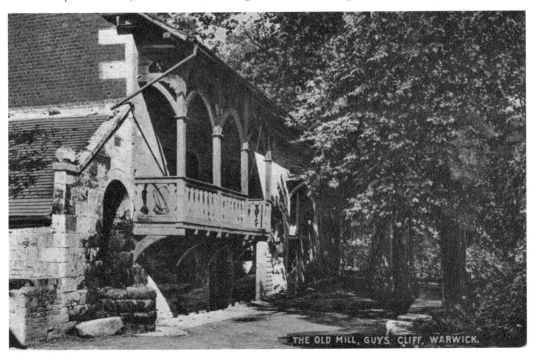

Warwick St Johns

The home of the County & Royal Warwickshire Regiment of Fusiliers Museum, St John's House was built on the site of the twelfth-century Hospital of St John around 1626. In the eighteenth and nineteenth centuries, St John's House was a school for educating young ladies.

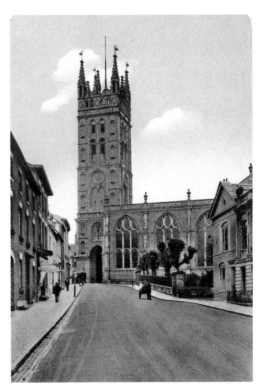

St Mary's Church, Warwick
Looking up towards St Mary's church, which dominates the town and the surrounding countryside and can be seen from miles away as you approach Warwick.

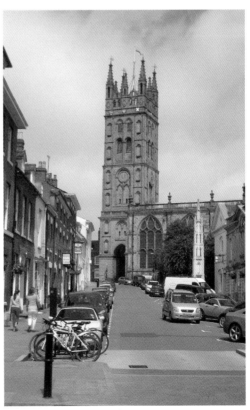

St Mary's Church, Warwick
You get a good impression of how close the timber-framed buildings were in 1694, creating a significant fire hazard.

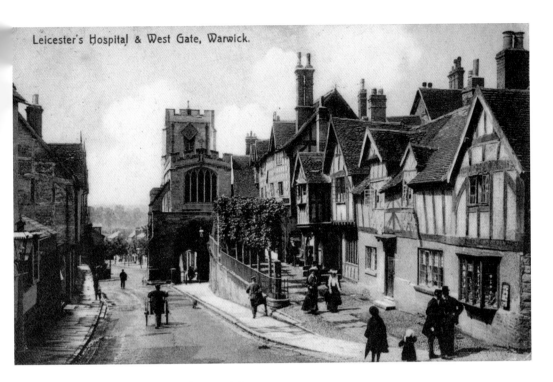

Leicester's Hospital & West Gate, Warwick.

The Lord Leycester Hospital, Warwick

The main building is the Master's House, and although it looks like a timber-framed Tudor building, it in fact has a Victorian front because the original front was in a bad state of repair and had to be replaced. Robert Dudley, Earl of Leicester, acquired Lord Leycester Hospital to house twelve of his retired employees. Locally, the hospital is always spelt Leycester.

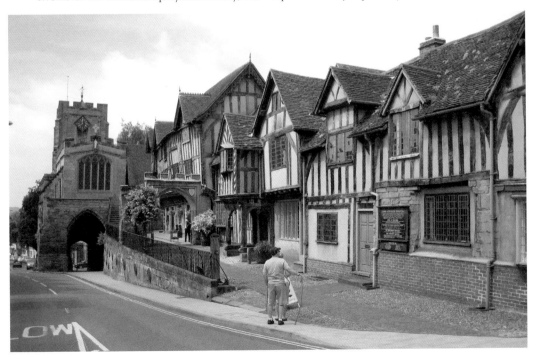

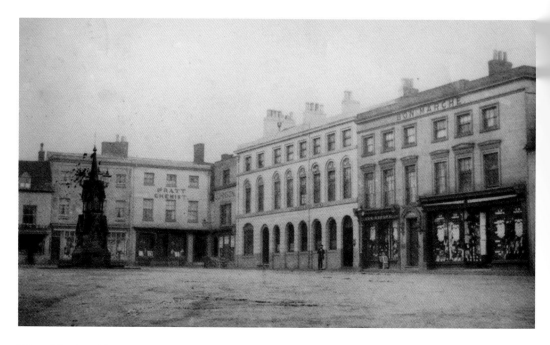

Warwick, the Shire Town

The great fire of 1694 in Warwick destroyed almost the whole of the town centre. It was rebuilt in the early eighteenth century, and the shire town now stands as proud as ever. In the top picture, we see standing in the middle of the square the fountain built to commemorate Queen Victoria and Prince Albert's visit to Warwick in June 1858. The bottom picture is the square today. Alas, the fountain is no more. The square is home to numerous shops, including Warwick Books.

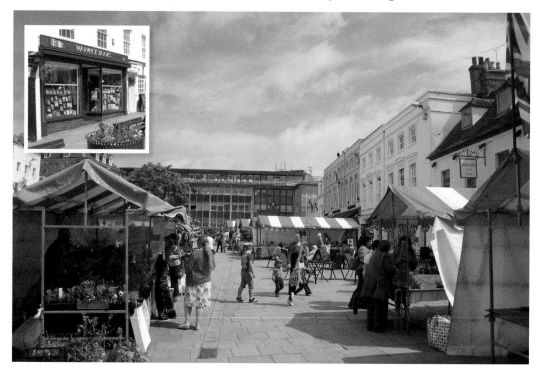

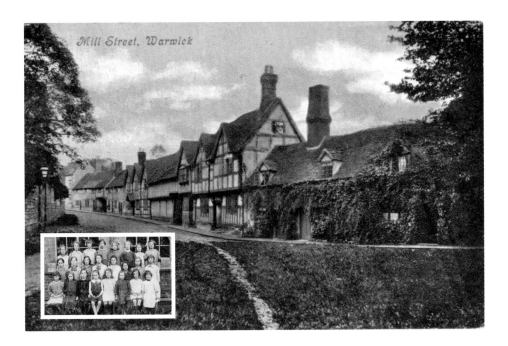

Mill Street, Warwick

The serious faces and dresses the little girls are wearing give a charisma and an insight into school-days fashion, in this case in 1922. The Borough School in Warwick was where Rhoda Skelsey was educated; she is the little girl sixth from the left on the front row. I have always loved coloured postcards, especially when they first appeared, and here we see Mill Street, Warwick. This picture is taken right at the bottom of Mill Street, and on the right we see Arthur Measure's lovely home. At the foot of the garden are the ruins of the fourteenth-century town bridge.

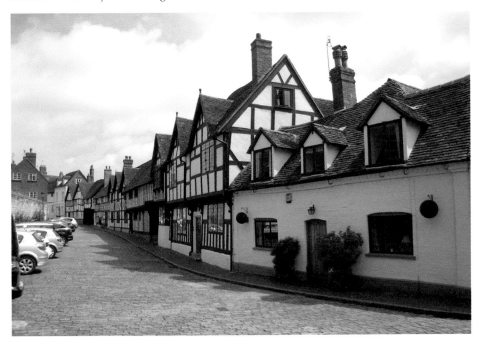

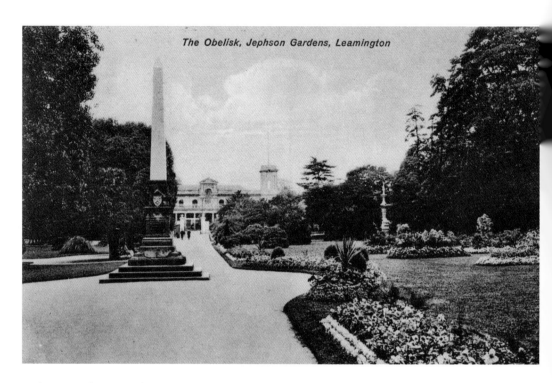

The Obelisk, Jephson Gardens, Leamington

Jephson Gardens, Royal Leamington Spa

Originally for the benefit of the residents of adjacent Newbold Terrace, the Jephson Gardens were acquired in 1846 by Dr Jephson, a much-respected practitioner whose patients included Queen Victoria and Florence Nightingale. Although the land actually belonged to Edward Willes, he generously leased it to the town for a peppercorn rent over a period of not less than 2,000 years, as Henry Jephson purchased the gardens for the people of the town.

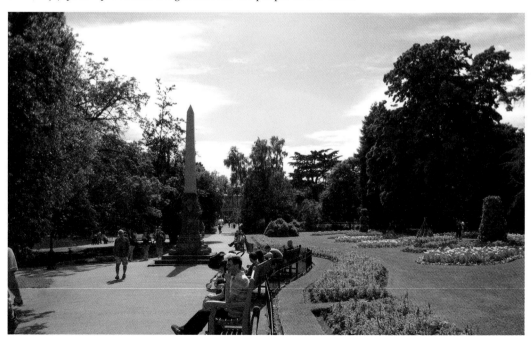

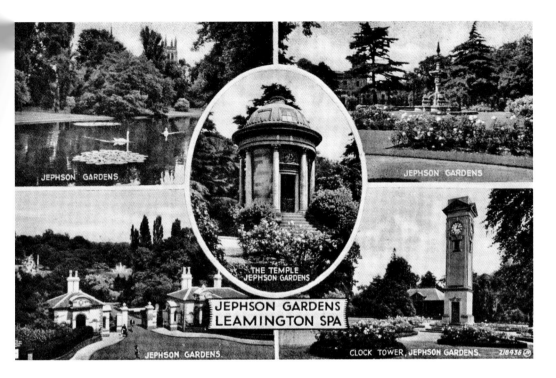

Jephson Gardens, Royal Leamington Spa

More views of Jephson Gardens, and in particular the clock tower. Jephson Gardens is very popular with locals and visitors alike when the sun is out. The tower has Westminster chimes, which is quite rare in a clock tower.

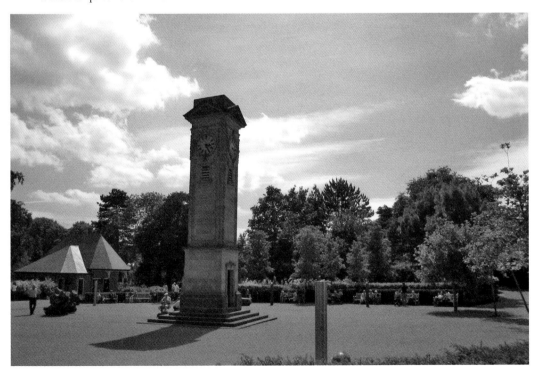

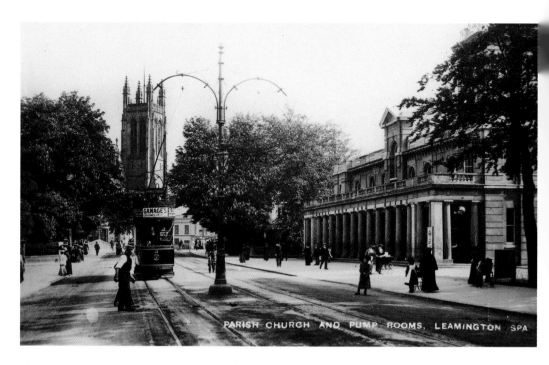

PARISH CHURCH AND PUMP ROOMS, LEAMINGTON SPA

The Pump Rooms, Royal Leamington Spa

I love this lovely old postcard of the Pump Rooms, which I came across in Cockermouth! It shows the Pump Rooms complete with weather tower, ladies in their finery and the tram making its way to the terminus in Avenue Road, outside the Manor House Hotel. One can almost feel the picture come alive, as it is complete with tramlines and ornate lamp posts. The parish church stands in the background. The inset postcard is of the Pump Room Gardens and shows the steps leading up to the suspension bridge that spans the River Leam, which leads on to the Victoria Park.

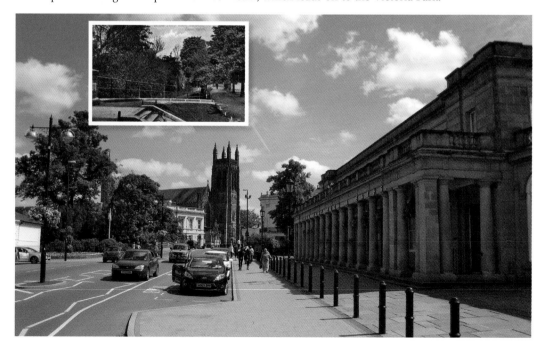

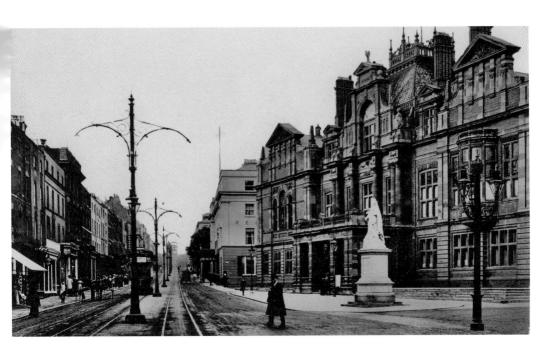

Town Hall, Royal Leamington Spa

I love this picture, with all the shop awnings pulled down to protect the goods in the windows from the sunshine. You could enjoy their shade on a very hot summer's day. It isn't until you see an old photograph like this that you realise the blinds have vanished. I can remember pushing my son in his Silver Cross pram up the parade, which runs straight ahead in the postcard, grateful for the protection the awnings offered when the sun shone and temperatures were high.

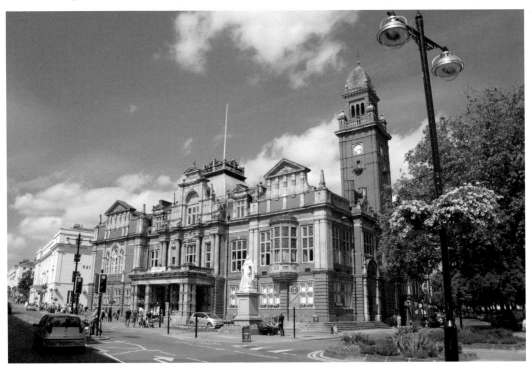

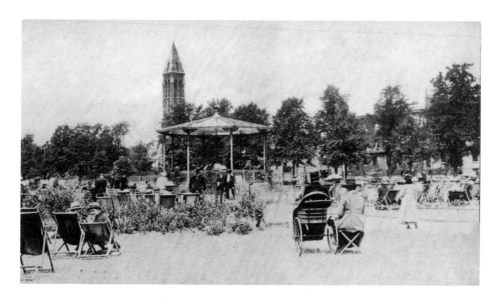

Pump Room Gardens, Royal Leamington Spa

The band still plays in the bandstand in the Pump Rooms on a Sunday afternoon in the summer months, although the deckchairs are no more and listeners now sit on the park benches placed around the bandstand to enjoy the music. The tranquil scene, seen inset, is Linden Walk viewed from along Dormer Place. The gold crowns on either end of the wrought-iron arches that spanned the Linden Walk were erected to celebrate Queen Victoria's Golden Jubilee, and the large glass globe in the centre was the gaslight, which would have been lit by the gas-lighter before nightfall. Although the arches were removed from this section of Linden Walk in 1971, I am very pleased to see that they have been reinstated again in 2012 to mark the Diamond Jubilee of Queen Elizabeth II.

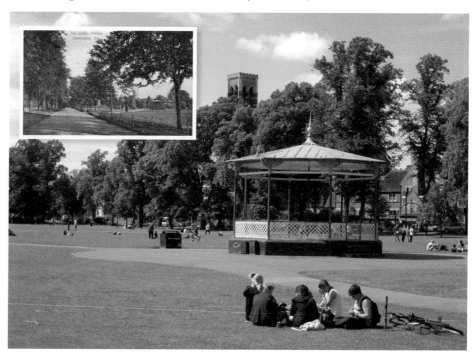

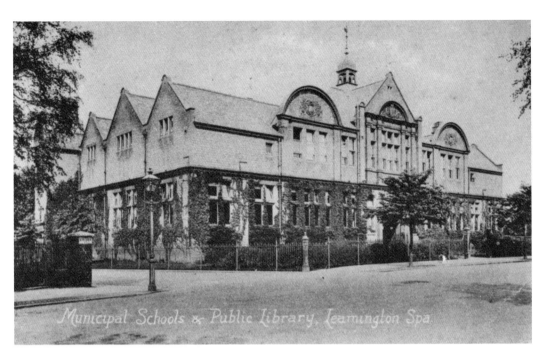

Leamington Spa Public Library

The Municipal Schools & Public Library, which stands in Avenue Road, was the town's main library for many years before it was rehoused in the Pump Rooms. On the right of the building was the town art gallery, which also moved into the Pump Rooms with the library. The building has been used by various organisations since, but only on a temporary basis, and its future is still under discussion.

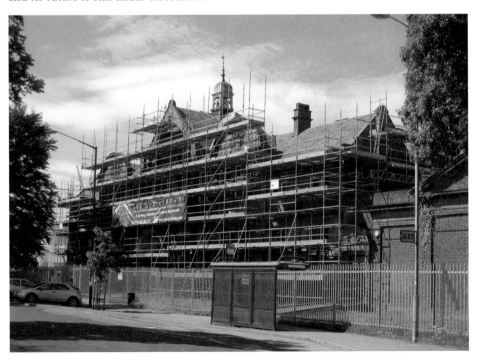

19

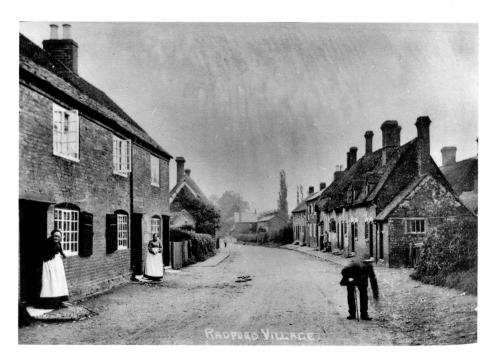

Radford Semele

Lying to the east of Royal Leamington Spa is the village of Radford Semele, a village that was once a separate settlement, but is slowly becoming a built up area as Royal Leamington Spa expands and houses are built on any spare land the builder can get his hands on. The village consists of mainly post-Second World War houses these days, although a few thatched and timber-framed cottages can still be found. Radford Hall and its beautiful, symmetrical Jacobean parish church of St Nicholas, which was practically rebuilt in 1889 only to fall victim to a vicious fire and has recently been refurbished, offers a lovely insight into Radford's past. The main road runs by the village and the White Lion pub is a fine example of a surviving thatched building.

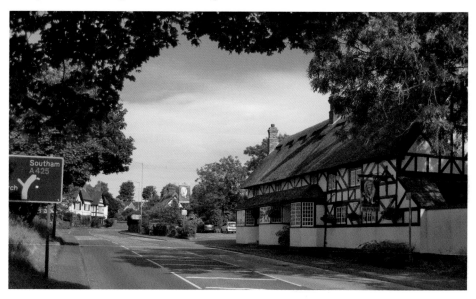

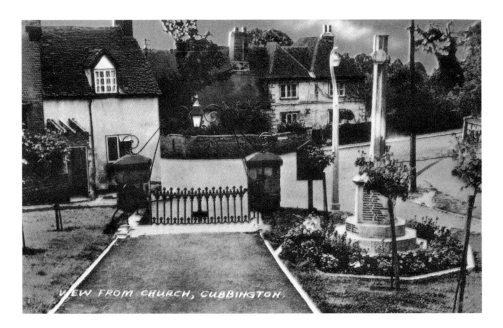

View from Church, Cubbington.

Cubbington

Situated on the north-eastern edge of Royal Leamington Spa, Cubbington has many claims to fame. Joseph Russell, the agricultural reformer, farmed here from 1780 to 1820. The revolutionary clover-head gathering machine was attributed to his genius. Mr L. B. Thwaites, who manufactured bumpers among other machinery, opened for business in 1938 and to this day is still manufacturing machinery on the site. The Norman church of St Mary also lays claim to fame, as from 1792–1820 the vicar was Revd James Austen, brother of the famous novelist Jane Austen. Not all events in the history of the village were good ones; in early 1605, galloping horses could be heard in the middle of the night and it emerged that on 5 November 1605, Robert Catesby, the gunpowder plotter, fled to Wales through Princethorpe, Weston under Wetherley and Cubbington on hearing the news of the capture of Guy Fawkes.

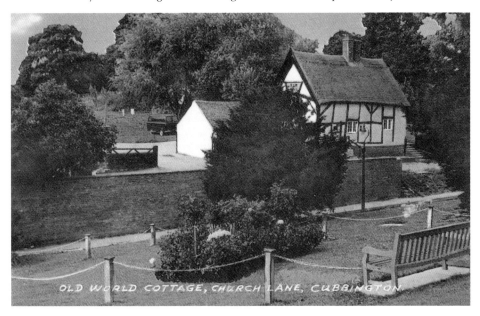

Old World Cottage, Church Lane, Cubbington.

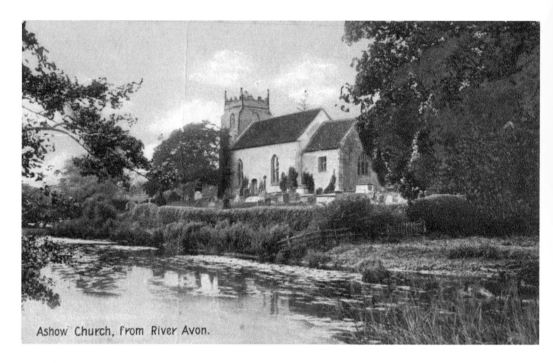

Ashow Church, from River Avon.

Ashow

Here we see a peaceful view of the River Avon as it flows past Ashow church. But don't be fooled; the houses seen in the bottom photograph stand the other side of the church, and in heavy rain they are prone to flooding. Taken in the 1920s, the photograph below is proof of just how destructive the river can be.

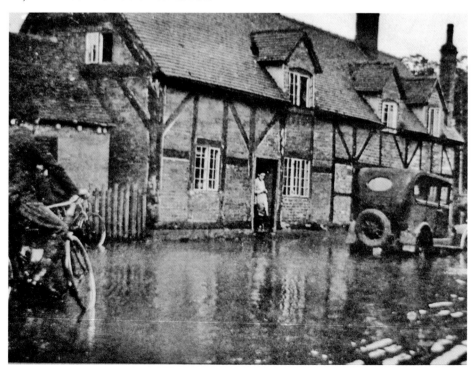

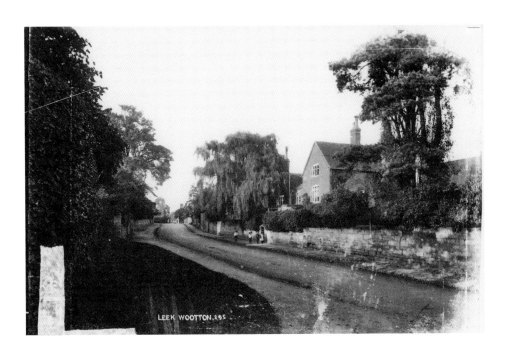

Leek Wootton

Leek Wootton was known as the Saxon town in the wood and lies south of Kenilworth. A house in the village, originally the home of the Waller family, was used as a military hospital during the Second World War, and the headquarters of the local police force from 1948. The church of All Saints in Leek Wootton stands on a rising bank above the road. A church has stood here since 1122. It is an interesting building, which has two stragglers from the Battle of Edgehill buried in the churchyard. On the grass lies an old Norman font. A beautiful silver gilt communion plate was presented to the church by Lady Alice, Duchess of Dudley. Hidden in the woods nearby is a memorial to Piers Gaveston, favourite of Edward II, who was beheaded on 3 July 1312.

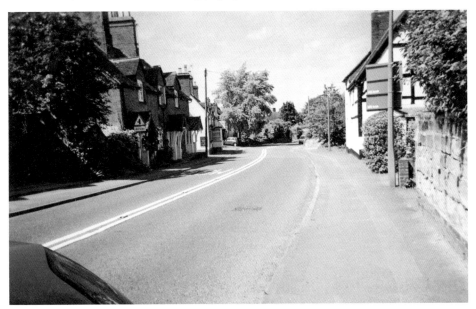

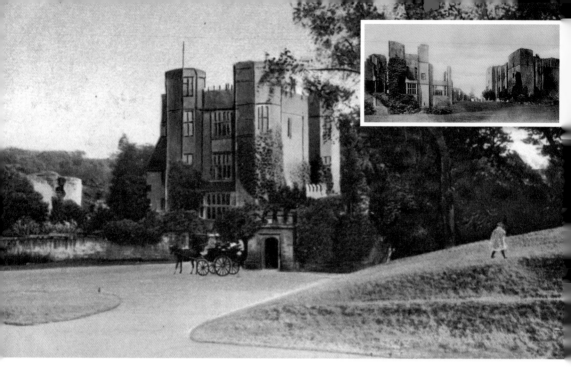

Kenilworth Castle

Built by the Earl of Leicester in 1570, the castle was converted into a permanent residence by one of Cromwell's officers in 1649. Here we have a look at the Kenilworth Castle gatehouse through time. One has the horse and carriage outside and the other some modern-day transportation.

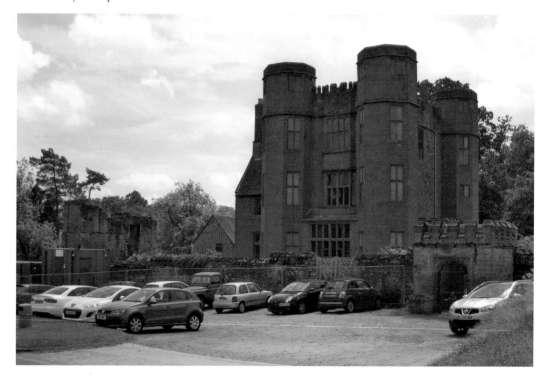

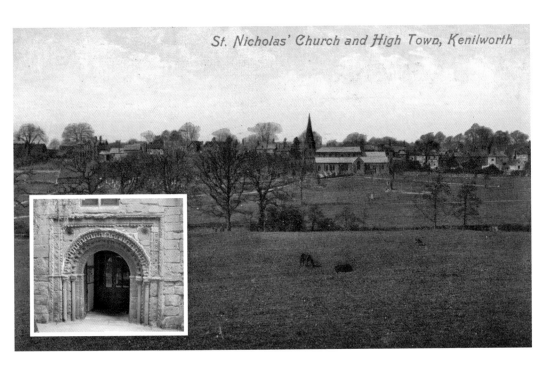

St Nicholas' Church, Kenilworth

Think of Kenilworth and you think of the castle, which was founded around 1120. Among its many claims to fame was the siege of 1266, which was the largest siege in English history. Kenilworth is divided into two halves, the original village near the castle and the modern commuter settlement, which extends around the present-day shopping area and beyond. St Nicholas' church has a beautiful Norman doorway (*inset*) that was originally part of the abbey. A small museum called the Abbey Barn stands in the Abbey Fields.

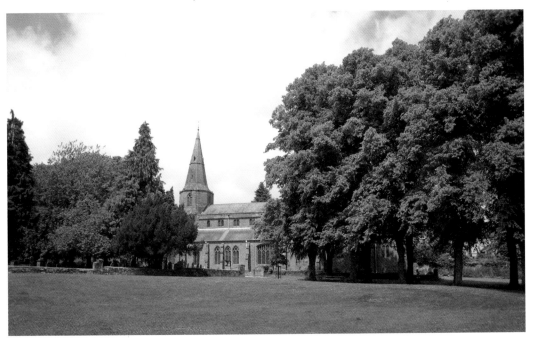

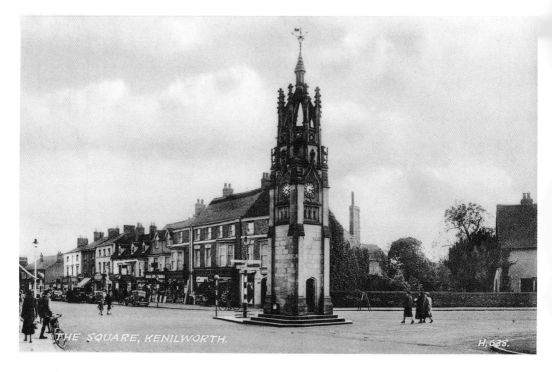

The Square, Kenilworth

Kenilworth is a historic Warwickshire town. Most people pass through it on the main route to Warwick, Leamington Spa and Coventry. However, it is steeped in history, from the dramatic castle and abbey ruins to the old town area, which centres on Bridge Street and High Street, north of the Abbey Fields.

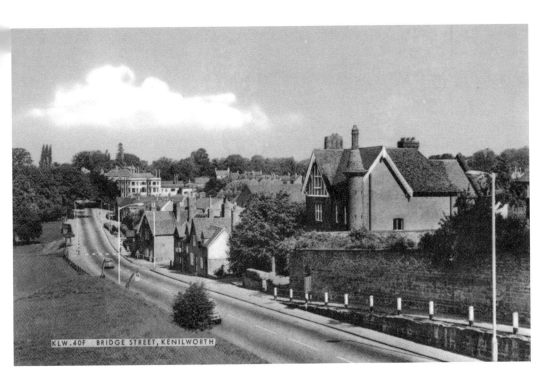

Bridge Street, Kenilworth

Bridge Street has changed very little over the years between these two views. St Nicholas' church can be found immediately to the left, just out of shot.

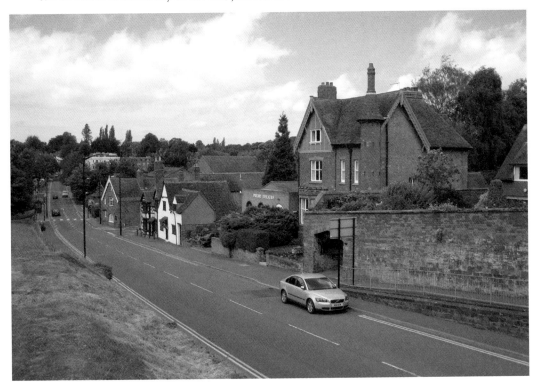

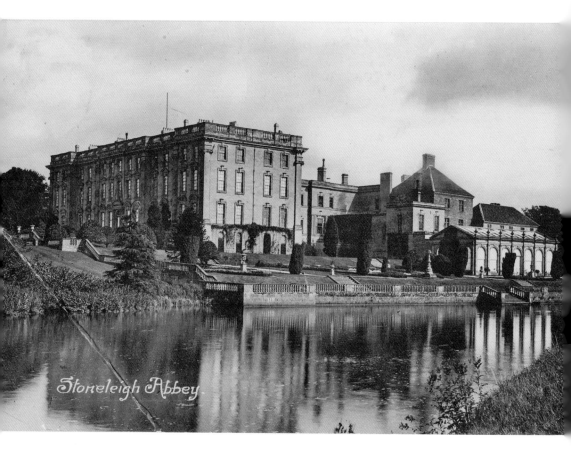

Stoneleigh Abbey

I visited Stoneligh Abbey as a visitor many years ago and have lovely memories of the delightful abbey and its grounds. It was built on the site of a Cistercian abbey founded in 1156. Although the house was out of bounds to the public for many years, until quite recently the annual Royal Agricultural Show was held in the abbey park. The popular Town & Country Show, held every year, has met its demise as well, and it was a sad day when these two very popular events were closed. Relatives of Sir Thomas Leigh, who was Knight Alderman of the city of London when the building came into his possession, still reside in the Abbey Gateway, which was converted into a house.

Coventry

Although Coventry now comes under the West Midlands after a boundary change, as it lies only 10 miles from the shire town, it is worthy of mention. Local opinion is that it should still be in Warwickshire, but the politicians felt differently! The stocks in the photograph to the left are odd as there are only five foot-holes visible. The bottom postcard shows Broadgate.

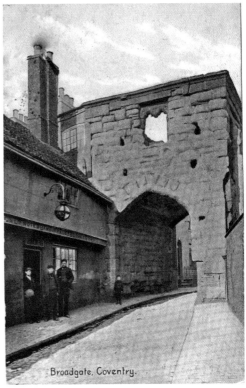

Broadgate, Coventry.

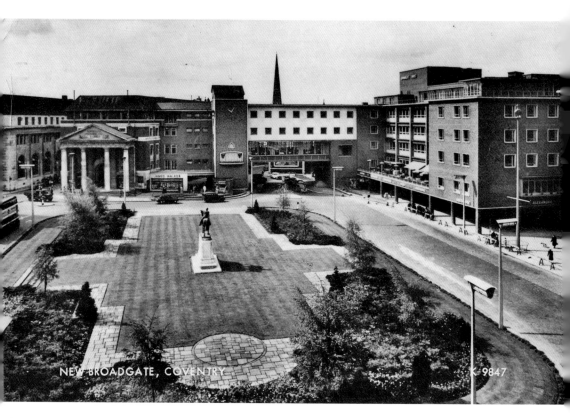

Lady Godiva, Coventry

When the postcard above and in the inset were taken, Coventry was in Warwickshire, and here we see Broadgate, complete with Lady Godiva, before the area underwent a facelift. It is nice to see how it used to look, and hopefully it will bring back happy memories for readers.

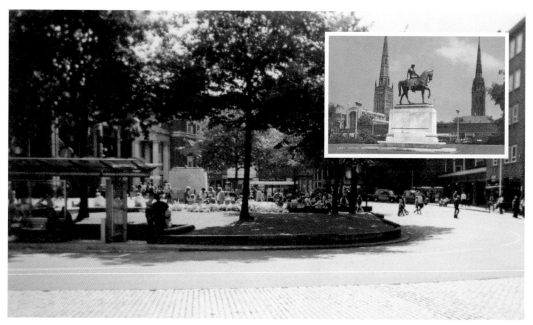

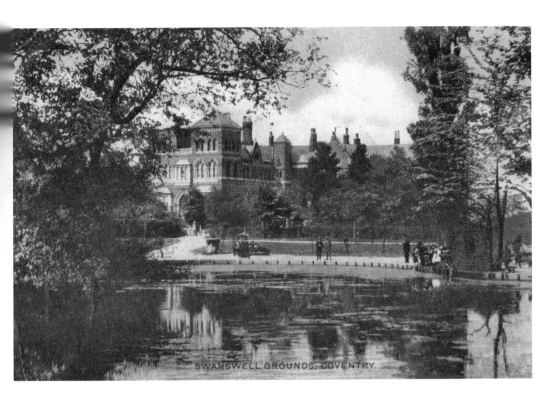

SWANSWELL GROUNDS, COVENTRY.

Coventry

Two lovely old postcard views of Coventry. The Swanswell in Coventry looks nothing like it did when this picture of the Swanswell Grounds was taken. It is certainly more peaceful here than it is today, as the bypass and main road around the city disturb the tranquillity. In contrast, the bottom postcard shows the beautiful church of St John. Life always seems so laid-back in these old pictures – no cars, no buses, no traffic lights, just heaven.

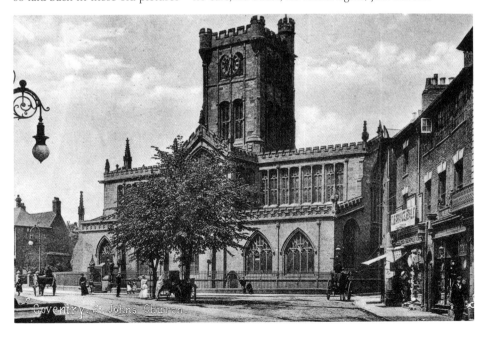

Coventry St Johns Church.

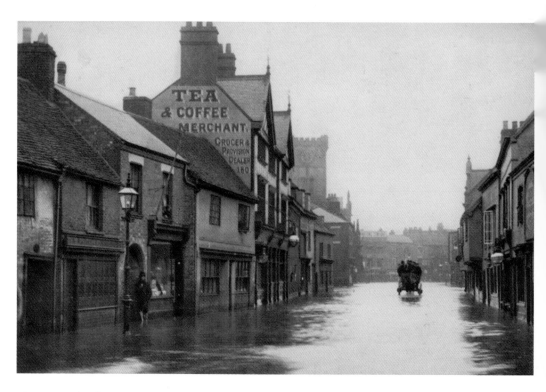

The Great Flood, Coventry

It is hard to imagine Spon Street flooded, but on 30/31 December 1900 it was a different story. Talking to the local vicar, I was surprised to hear that it floods to this day when we have heavy rain and the river rises.

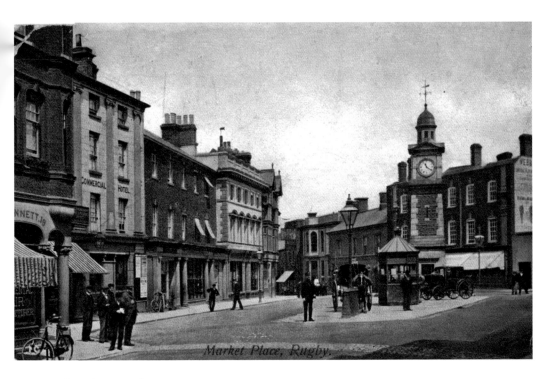

Market Place, Rugby.

Market Place, Rugby

To the extreme east of the county lies Rugby, a market town famous for the Rugby School and the eponymous game. As you look up the road from the Market Place, you can see the school, which dominates the centre of the town. Also situated near the town centre is Caldecott Park, which has recently undergone a facelift. The Market Place is considerably more leafy today and the various shops have changed a number of times in the years between these two views.

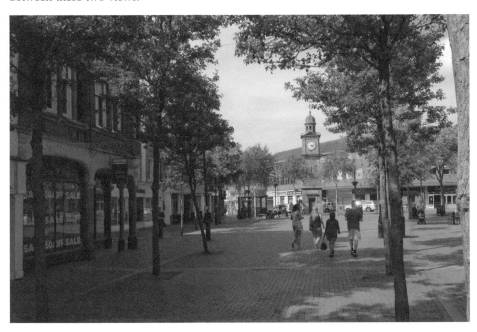

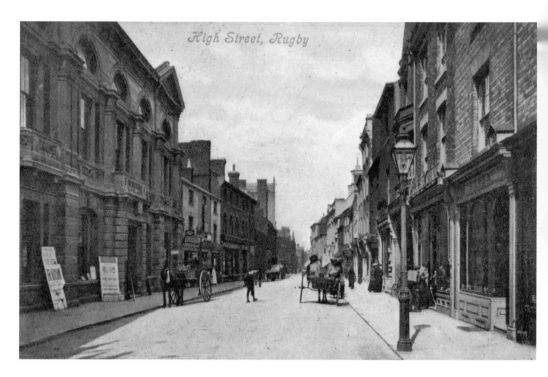

High Street, Rugby

Recorded in the Domesday survey as a dependency of Clifton on Dunsmore, Rugby became independent in the thirteenth century. Lawrence Sheriff, who was born here, had a successful grocery business in London. He supplied the future Queen Elizabeth with spices in the early Tudor period. The High Street has changed a great deal over time and the motor car has now taken over from the horse and cart, though most of the town centre is pedestrianised.

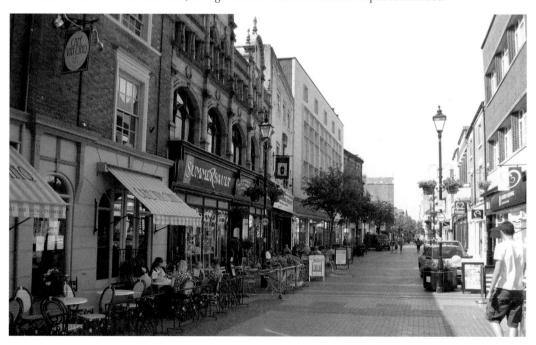

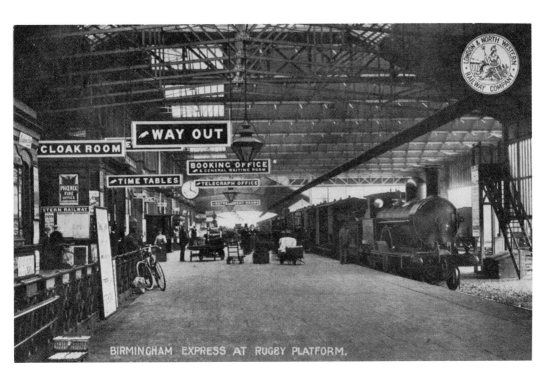

BIRMINGHAM EXPRESS AT RUGBY PLATFORM.

Rugby Station, Rugby

The Birmingham Express stands at Rugby station. This image brings back lots of memories: the cloakroom, booking office, timetables and refreshment rooms, not to mention all that steam when the engine started to roll. Life was so much simpler in those days. What makes this postcard interesting is the crest in the right-hand corner, which reads London & North Western Railway Company, November 1905.

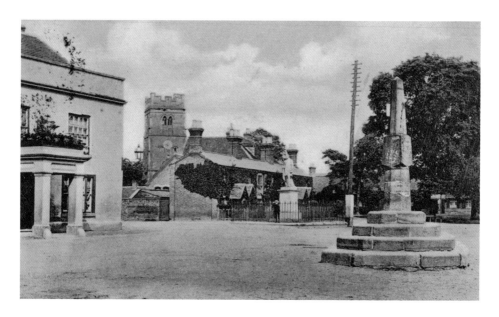

Dunchurch

In 1086, Dunchurch, as it is known today, was known as Don Cerce. Because of its location on the old coach road from London, in times past it boasted no less than twenty-seven alehouses. Dunchurch is also famous for its association with the Gunpowder Plot, as the place the conspirators took refuge on their flight from the law. Longfellow was also familiar with the area and his poem, 'The Village Blacksmith', was based on the smithy here, which still stands, much to the delight of the visitors who come to photograph it. The building is now a private house called 'The Old Forge'. The parish church of St Peter has a mention in the Domesday survey and is still very popular with the village residents who regularly attend services there.

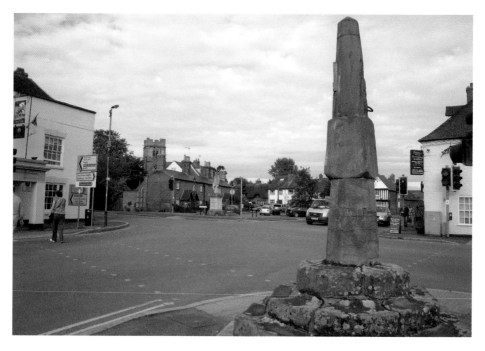

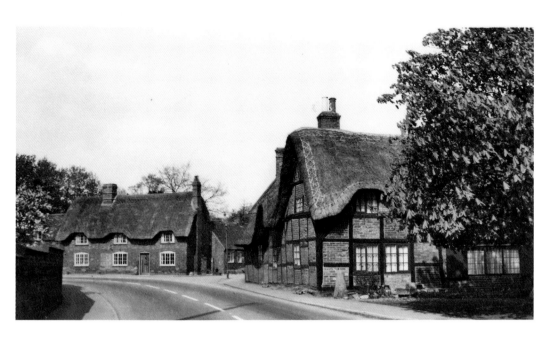

The Old Forge, Dunchurch

Smithies were once a common sight in Warwickshire and Dunchurch was no exception. Standing on the Old Coach Road from London, the Smithy in Dunchurch would have enjoyed good business from the horse-drawn carriages. However, with the decline in horse-drawn vehicles and the introduction of the motor vehicle, the Smithy went out of business and the premises have been converted into a private residence, aptly named 'The Old Forge'. The decorated lamp posts are a nice addition.

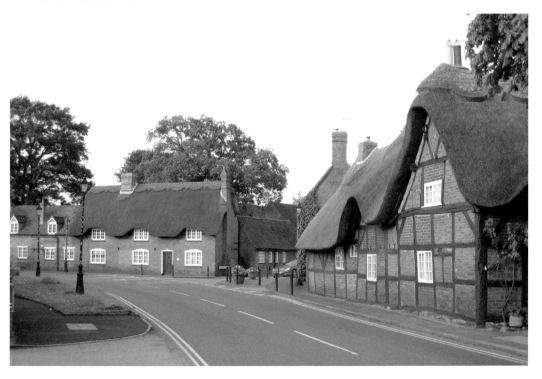

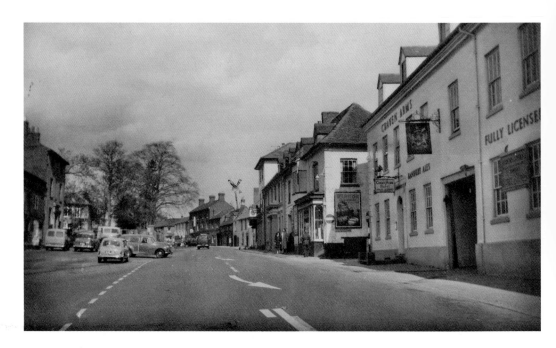

Market Hill, Southam

The discovery of Roman coins in the nineteenth century in Bury Orchard suggests that there was a Roman settlement in Southam around AD 150–250. The town is recorded in the Domesday survey. Prior to the Civil War, Charles I passed through the town, only later to return before the Battle of Edgehill. Cromwell was also in Southam in 1645, with 7,000 troops. Up until 1820, four annual fairs took place, the most important being the Charter Fair, established in 1257. One place of interest in Southam is St James parish church, which was built in Perpendicular style in the sixteenth century. The pulpit dates back to the late sixteenth century and in the tower is a peal of eight bells.

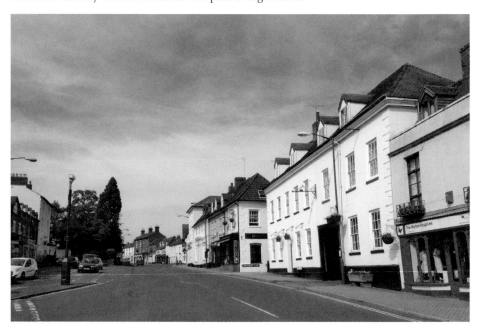

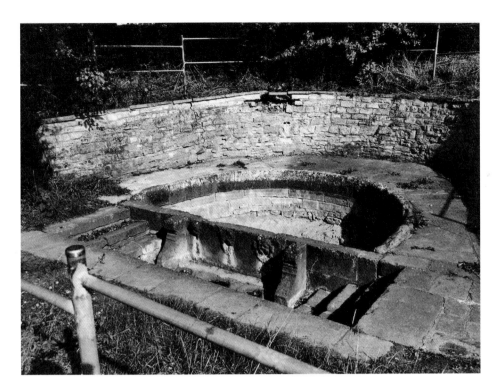

Southam Holy Well

The well was first mentioned in 998 and is Grade II listed. The water from the well is intensely cold and came to be regarded as a cure for eye ailments. Arthur Mee wrote in his book, *Warwickshire*, 'Southam has a Holy Well that never freezes and a street that always pleases.' It is not the easiest place to find, but if you don't mind a walk it is well worth the effort.

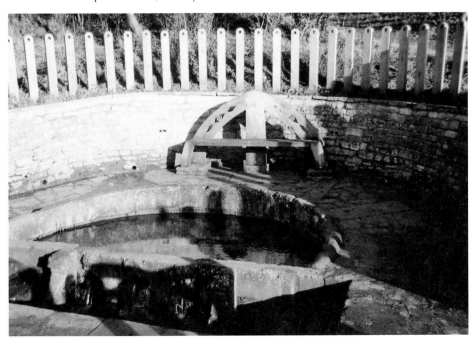

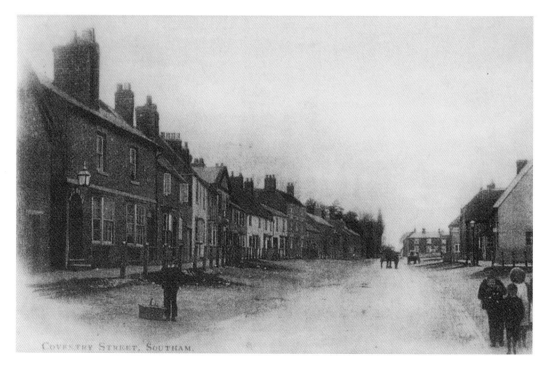

Coventry Street, Southam

Above is a very old picture of Southam, and the quiet roads shown are a far cry from the heavy traffic that passes through the village today. Southam has a number of important roads running through it: the Coventry to Oxford Road, the famous Welsh Road used by the cattle drovers, and the London to Birmingham via Daventry Road.

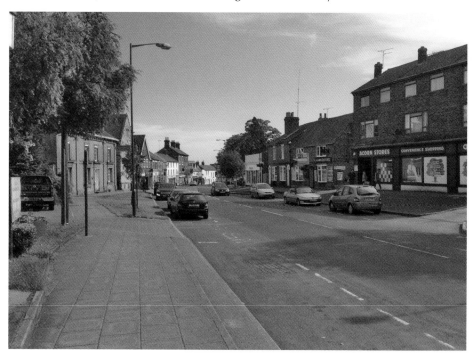

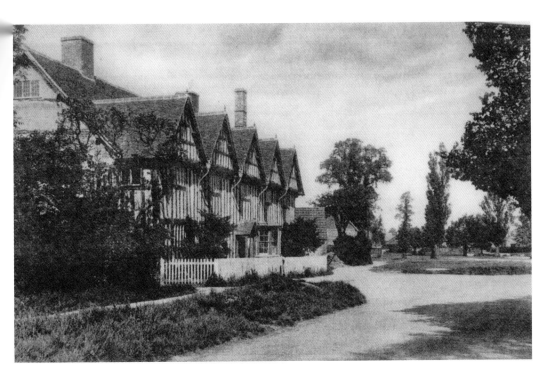

Long Itchington

These lovely old houses can be found in the centre of the village. On the right is the village pond, affectionately known by the older generation as the pit, as they would remember the marl being dug out to cover the light sandy soil and the water that filled the hole left there. To this day the pond remains the focus of village life. Timber-framed buildings sprang up all over the Midlands during the fifteenth to eighteenth centuries. The oldest building in the village is the church, which stands near the River Itchen, from which the village takes its name.

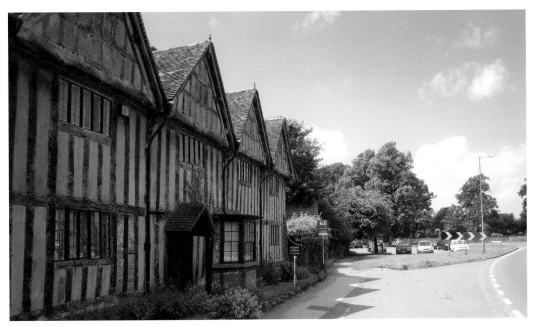

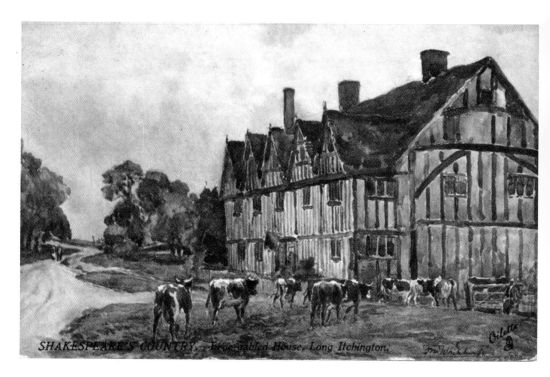

SHAKESPEARE'S COUNTRY.—Tree-gabled House, Long Itchington.

Long Itchington

This property is currently for sale and could do with some tender, loving care. The chances of seeing livestock grazing on the verge is very unlikely today; not least because of the very busy main road.

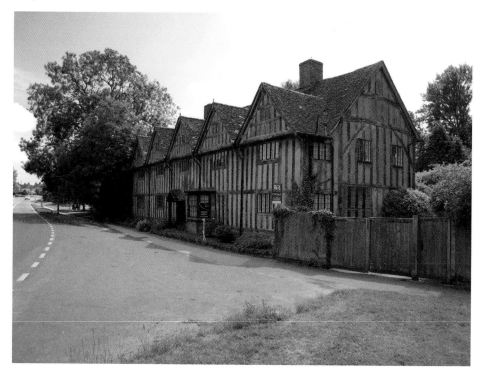

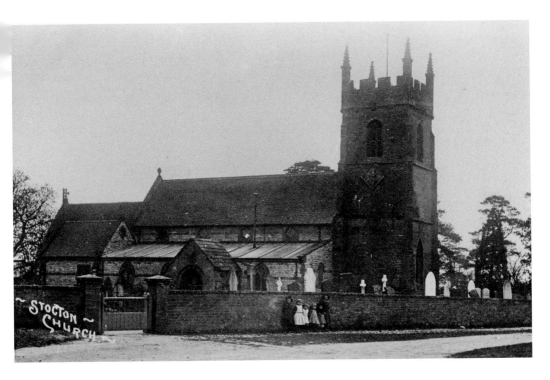

St Michael's Church, Stockton

This old church at Stockton by the village green has undergone many alterations over the years. The nave and north aisle were rebuilt in 1863. The fifteenth-century west tower is embattled and pinnacled. The church register dates back to 1560. Noted for the Blue Lias limestone work, it has a large boulder of great geological interest.

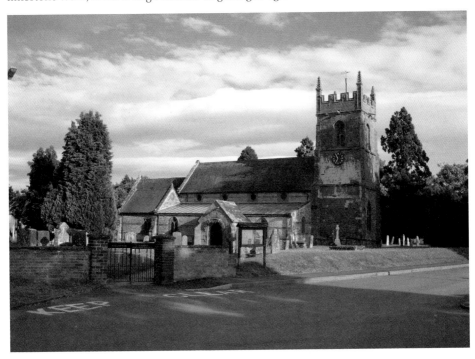

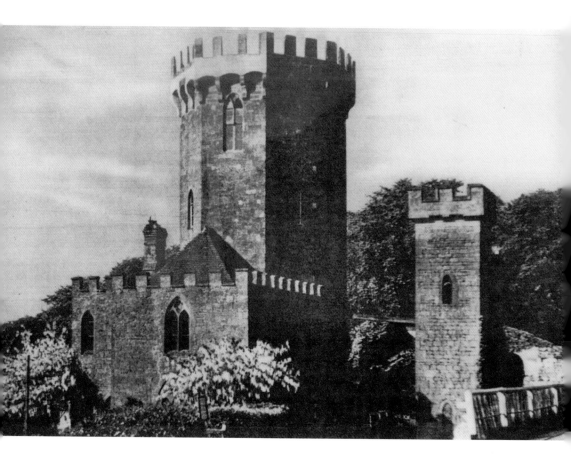

Edgehill

Built in 1750 to mark the point where King Charles's army was posted before the famous Battle of Edgehill between the Royalist and Parliamentary forces, the octagonal stone tower is an impressive site on the top of the Edgehill. Since this time, the tower has been refurbished and an extension added and it is now a popular public house, where not only can you enjoy a pint of beer, but also admire an extensive view towards Kineton. The locals claim that to this day the ghostly sounds of that famous battle can still be heard on a dark 23 October evening!

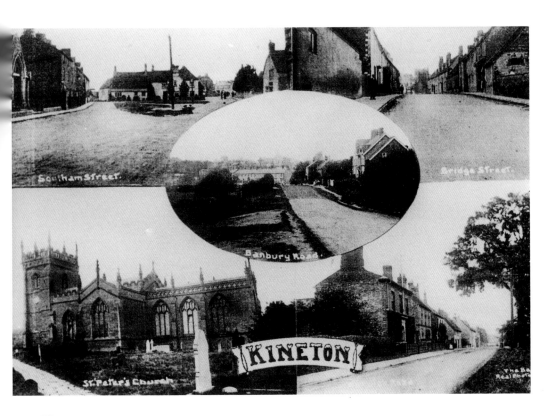

Kineton

Kineton was a royal domain before the Norman Conquest and was later to become the home of King John. Just outside the village lies Little Kineton, sometimes referred to as Lower Kineton. The Wesleyan Methodist church in the village was erected in 1893. The village school closed and was used as a doctor's surgery. The medieval church of St Peter stands in the heart of the village.

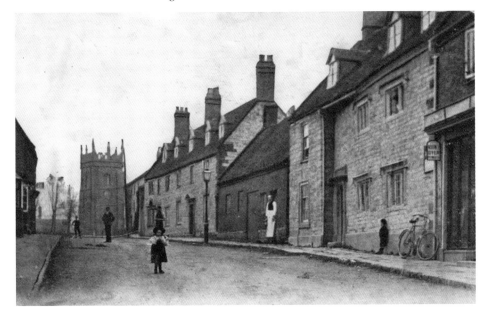

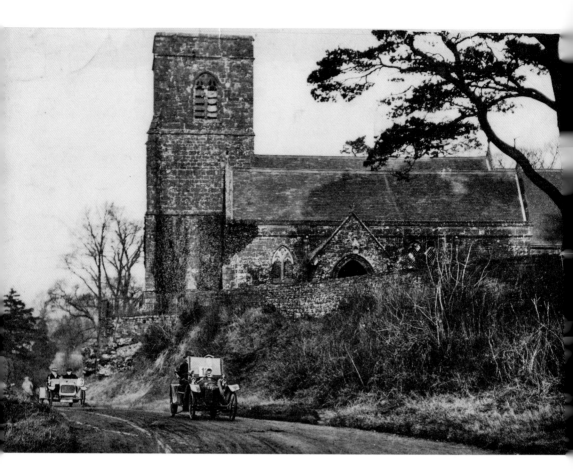

Warmington

Situated some 6 miles from the market town of Banbury, the village of Warmington is built mainly in the local ironstone around a large green. This stone is unusual insofar as it glows honey-coloured in the sunshine, giving the village a charisma and charm all of its own. Dedicated to St Michael, the church is built on a hilltop and overlooks the village. The church is unique, as above the vestry, which was originally a chapel, is an upper room where the priest lived in times past. In the churchyard are around eighty listed gravestones. Standing in the vicinity of Edgehill, it comes as no surprise to learn that one of the memorial stones was to Alexander Gourdin, a Royalist Captain who fell at the Battle of Edgehill.

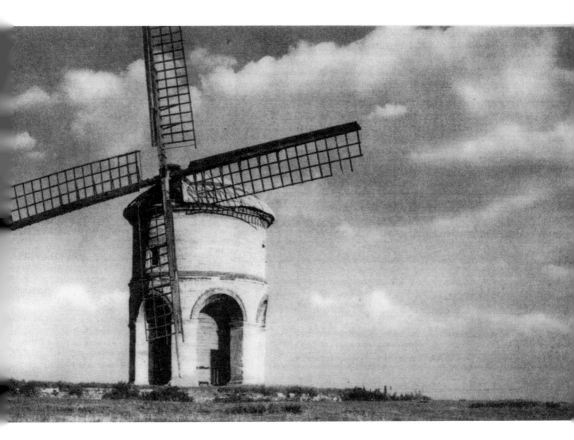

Chesterton Windmill

Dominating the skyline, the Chesterton Windmill, erected in 1632 by Sir Edward Peyto, is an impressive sight as you travel along the Fosse Way in Warwickshire towards Cirencester. The design was attributed to the famous architect Inigo Jones, but it has also been suggested that master mason to Charles I, Nicholas Stone, had a hand in it, as he had at the time been involved with the monuments of the local church. First used in 1647, when the sails were added, the windmill was in service until 1910.

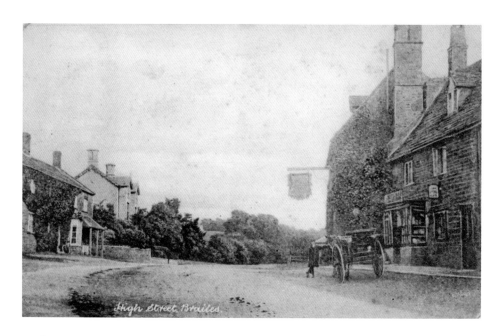

Brailes

How could you not fall in love with the tranquillity captured in these lovely old postcards? Here we see Brailes High Street, which lies at the southernmost tip of Warwickshire. Brailes is divided into two parts, upper Brailes and Lower Brailes, with Brailes Hill being the second highest point in the county. In medieval times it was the third largest market town in the county. The centre of Brailes has a number of old stone buildings in traditional Cotswold design. The High Street passes Brailes House and its well-wooded grounds. In the village centre is an old cross, while in the north of the parish, on higher ground, is the parish church of St George, one of Warwickshire's most interesting churches. It is known as the 'Cathedral of the Feldon'. Its Perpendicular-style west tower stands 120 feet high, making it the largest church in South Warwickshire.

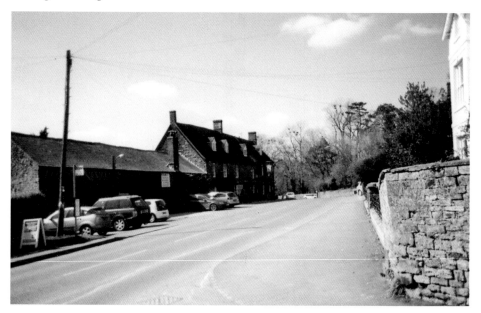

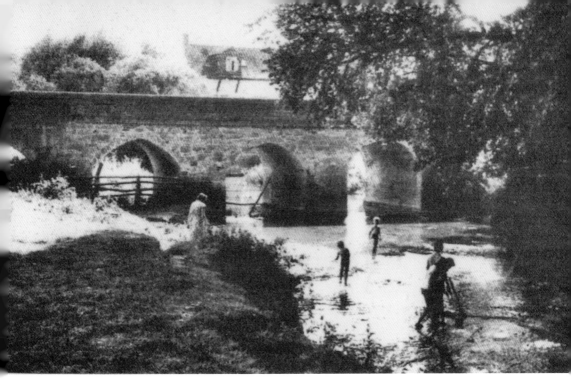

Shipston-on-Stour

An old market town, Shipston-on-Stour is mainly full of lovely old Georgian buildings. The church that can be seen in the bottom postcard is the parish church of St Edmund and was rebuilt in 1855. The old coaching inns, the Horseshoe, the George and the Bell, are still standing. The children seen playing in the shallow waters of the River Stour and the bridge that spans it portray a tranquil scene of days past.

Bradley's Bazaar, Shipston Market Place

49

Charlecote

The nineteenth-century red-brick mill stands near a single-span iron bridge. Charlecote watermill is now a working mill again after many years, and is often open to the public. The iron bridge was cast by the Horseley ironworks in Shropshire in 1829, and is one of the earliest iron bridges in the country. Charlecote House (*inset*) is one of the National Trust's most popular properties. It was given in 1189 by William de Montford of Beaudesert, near Henley-in-Arden, to Thurstane de Cherlcote. It was presented to the National Trust by Sir Montgomery Fairfax-Lucy in 1946. Once linked to it by a ford but now by bridges, Hampton Lucy lies half a mile from Charlecote on the opposite side of the River Avon. The house has altered very little since Edwardian days, though six lime trees that were planted as saplings to commemorate the births of children of Charlecote Park have now matured, while the children they represented have passed away.

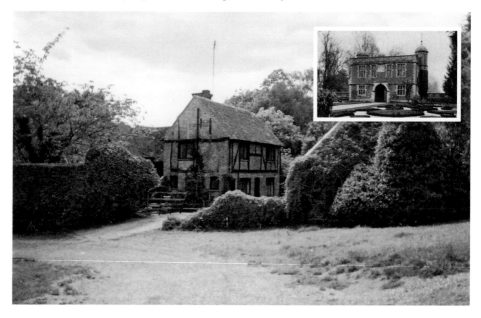

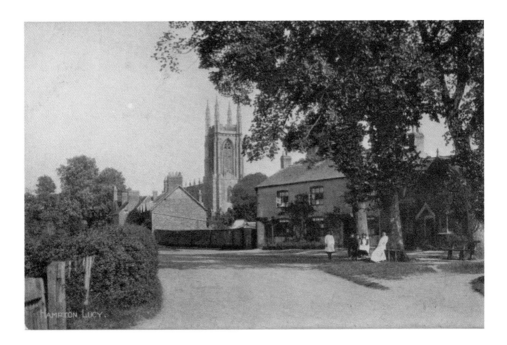

Hampton Lucy

Hampton Lucy lays half a mile from Charlecote on the north side of the River Avon, which skirts the village, while Charlecote is on the flat Feldon south side. One of the earliest iron bridges in the county crosses the Avon at this point. Hampton Wood, which comes under the jurisdiction of the Warwickshire Nature Conservation Trust, is on the north-east edge of the village. Earthworks have been found in the wood that suggest it was probably part of the boundary of the Lucy deer park. Since the sixteenth century the village has been connected to the Lucy family at Charlecote and several cottages in the village were once Lucy estate properties. Hampton Lucy once had a medieval church, which was rebuilt in the nineteenth century.

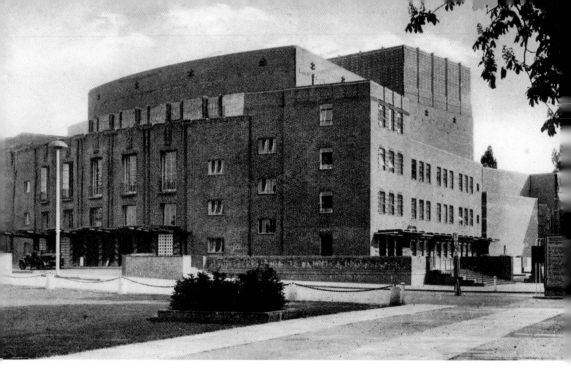

Stratford Theatre

Shakespeare Memorial Theatre has just undergone a refurbishment and looks nothing like the top postcard view, which is very much how I remember it as a child. I love the inset view as it is full of charisma, showing the entrance foyer of the Shakespeare Memorial Theatre full of mystery and expectation, waiting for the audience to appear.

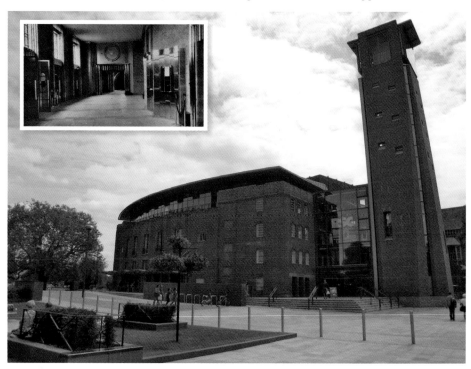

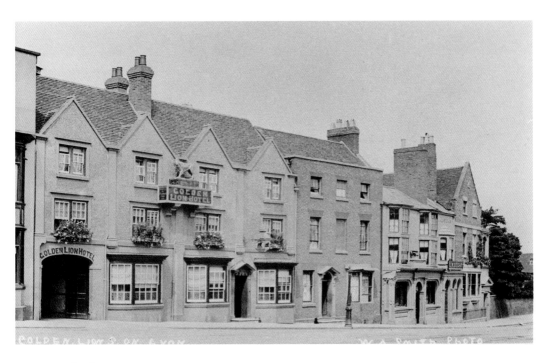

Stratford upon Avon

Situated in Bridge Street, the Golden Lion was first licensed as the Peacock Inn in 1612. It was a bustling coaching inn with a yard for stabling and carriers across to Guild Street behind. It did not enjoy the best of reputations in the 1870s, with complaints about gambling, drunkenness and prostitution. Marks & Spencer now trade on the site.

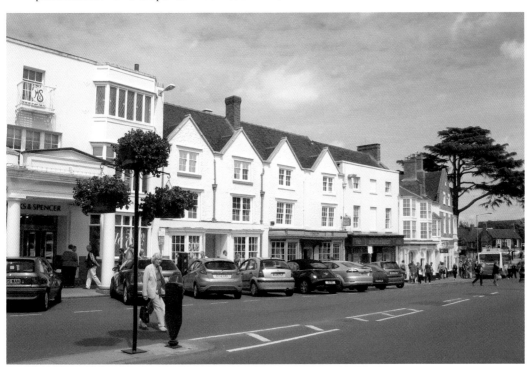

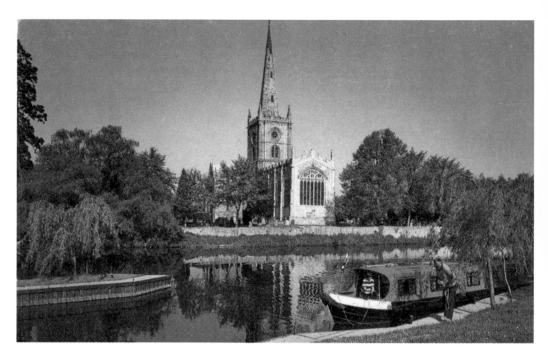

Holy Trinity Church, Stratford upon Avon

Two views of Holy Trinity church taken from across the river. In the view above a canal boat, so much a part of the Stratford upon Avon scene these days, is moored on the opposite bank to the church. The inset shows the inside of the church, in particular the choir stalls.

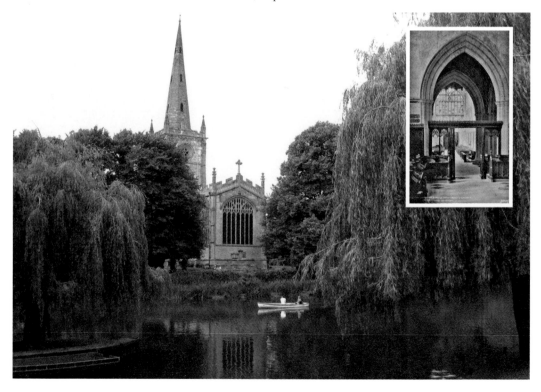

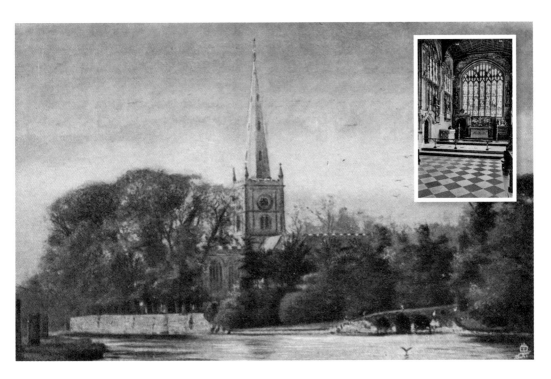

Holy Trinity Church, Stratford upon Avon

Here we see the large east window in the church (*top inset*), which depicts the crucifixion. The altar tombs contain the remains of Dean Balsall, who died in 1491 and was the man responsible for the rebuilding and modification of the chancel, and John Combe who passed away in 1261. In the inset below we see the Lady chapel.

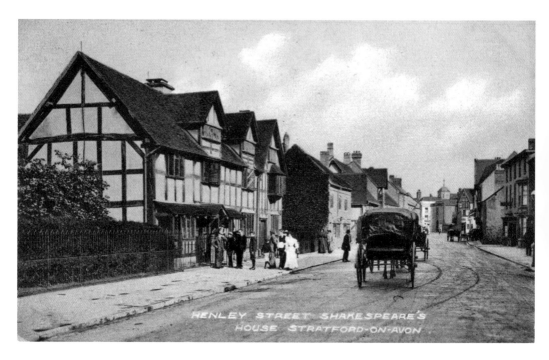

Henley Street, Stratford upon Avon

A lovely view of life in Henley Street, when tourists were far and few between, and life took on a more sedate pace. While in contrast, we see in the photograph below the same view as it is today! On the back of the inset postcard is written 'I saw all these people this afternoon all in fancy dress' – all these people being the apprentices at Shakespeare's England.

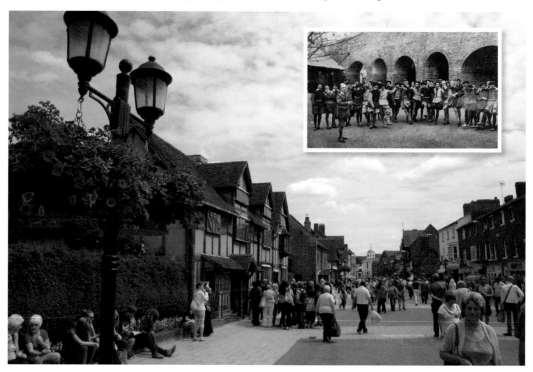

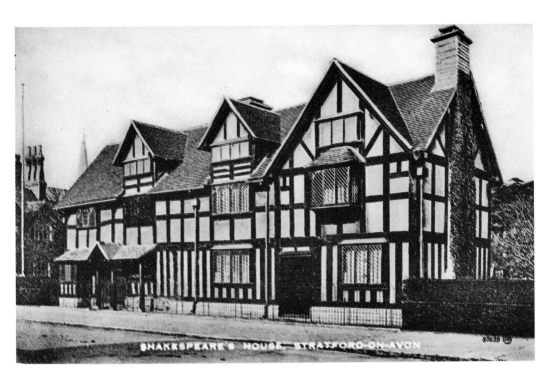

Shakespeare's House, Stratford upon Avon

Famous as the place where William Shakespeare was born in 1564, the house has been altered many times over the years. The barns, outhouses, piggeries and brewhouses were demolished to make way for the garden.

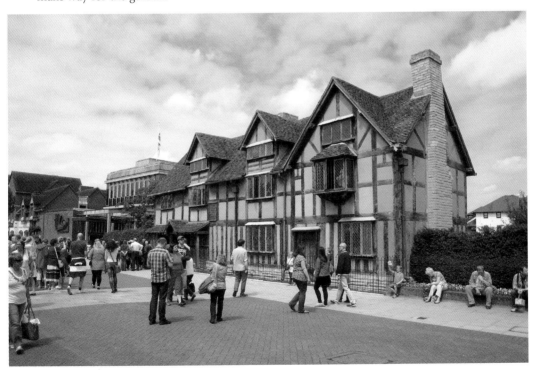

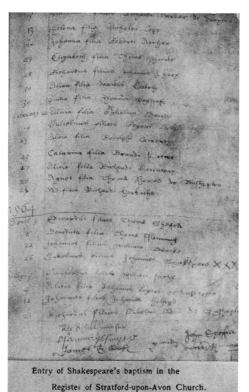

Entry of Shakespeare's baptism in the
Register of Stratford-upon-Avon Church.

William Shakespeare, Stratford upon Avon
I was delighted to find these two lovely old postcards in Cumbria, of all places! The top postcard shows the entry to Shakespeare's baptism in the register of Stratford upon Avon church, while the bottom postcard shows the entry of his burial.

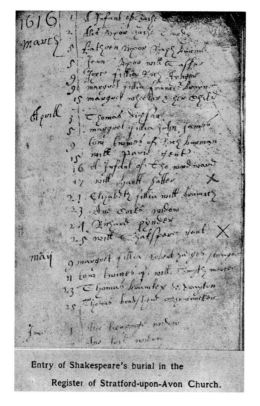

Entry of Shakespeare's burial in the
Register of Stratford-upon-Avon Church.

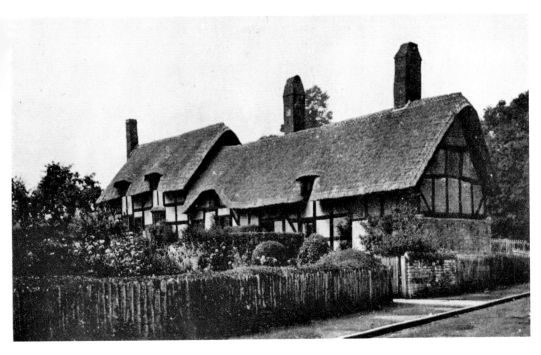

Anne Hathaway's Cottage
Originally called Newland's Farm, the name of the cottage was changed to reflect the fact that it was the childhood home of William Shakespeare's wife, Anne.

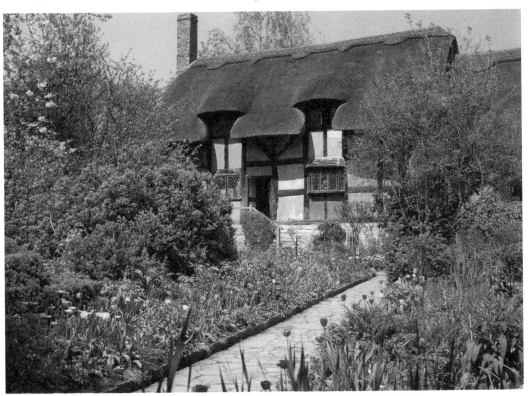

Snitterfield

These lovely old thatched cottages were certainly photographed when Snitterfield enjoyed a traffic-free life in the early 1900s. Standing on a hilltop outside the village is the most dramatically sited war memorial in the county, overlooking the beautiful, wide expanse of the Feldon and Avon Valley. The Illmington Brass Band played at the opening ceremony. My father recalled them missing out the last verse of the hymn and those stood round the memorial for the opening ceremony singing the last verse unaccompanied.

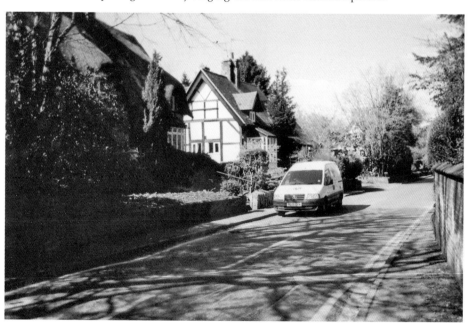

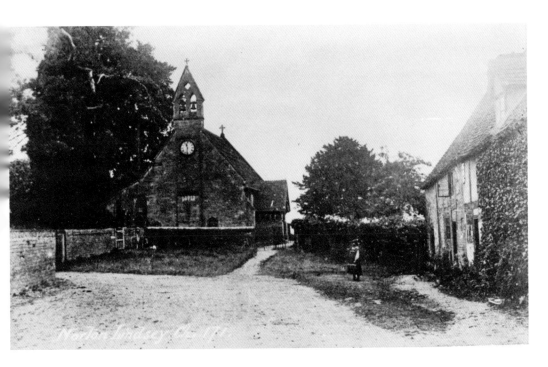

Norton Lindsey

Situated 4 miles from the county town of Warwick and 6 miles from Stratford upon Avon is Norton Lindsey. Its parish church dates back to the thirteenth century, but it has an eleventh-century font. It lies at the end of a small lane, and a row of lovely old black-and-white cottages lines the right-hand side of the lane leading up to it. As you approach Norton Lindsey there stands a rather beautiful and unique metal signpost, erected as a memorial to the Diamond Jubilee of Queen Victoria. The village also has an old windmill dating back to 1795. No longer a working mill, the building is slowly being restored by the owner.

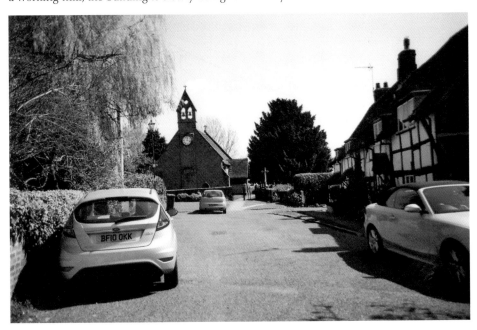

Wolverton

I have happy memories of Wolverton. My father used to speak of the days he grew up there. Once a week, the organ grinder visited the village and my grandmother would save four farthings so that she could pay him a penny to play her favourite hymn, and then she would sing the hymn over and over again for the rest of the day. Wolverton is actually joined up with Norton Lindsey. Its parish church of Holy Trinity dates back to the thirteenth century and it still has fragments of medieval glass in some of its windows. Wolverton Primary School was built in 1876 and its pupils come from Wolverton, Norton Lindsey and the surrounding area.

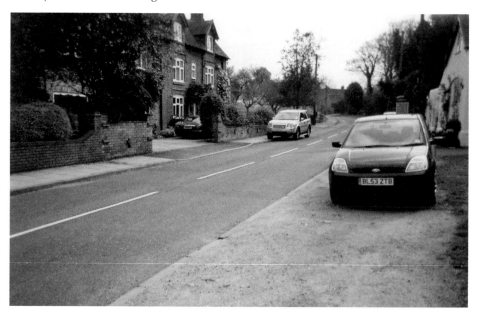

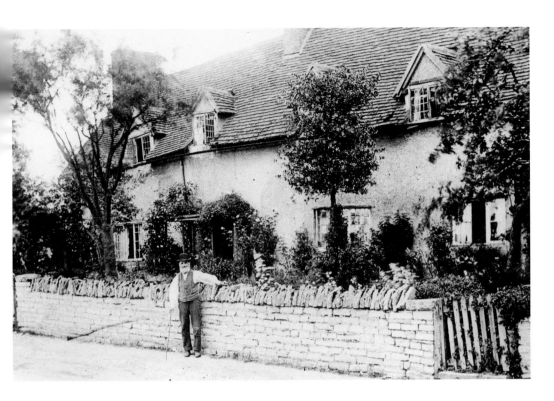

Wilmcote

Wilmcote was once part of Aston Cantlow parish. It has many places of interest within its village boundary, including the Victorian Gothic railway station with its decorative bridge and Mary Arden's house, which was the former home of Shakespeare's mother. There are those who believe the house was left to her on the death of her father. The house dates back to the early sixteenth century, but was first called Mary Arden's House in 1789.

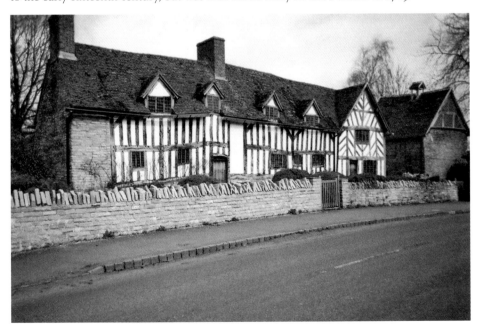

Wilmcote

Just 3 miles north of Stratford upon Avon lies the picturesque village of Wilmcote. The village church of St Andrew stands next to the village school and has a beautiful and well-kept lychgate, which is a special love of mine as there are some lovely ones around the county. The church has a very large burial ground, and in days gone by the lychgate would have probably been in frequent use for the transfer of pauper's bodies onto the bier, where they were pushed to the church and the communal burial ground. The coffin was then free to be used again.

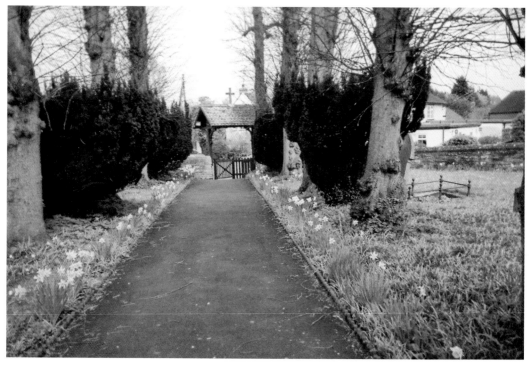

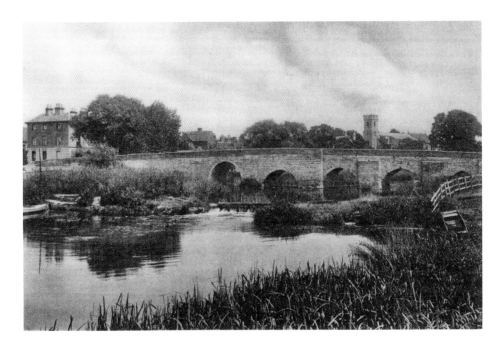

Bidford-on-Avon

Downstream from Welford-on-Avon is Bidford-on-Avon. As the name suggests, Bidford lies on the Avon, at the point where the Roman Ryknild Street forded the river on the way to Alauna, better known as Alcester. In time, the ford was to be replaced by the eight-arch medieval bridge seen it in this picture. It survived a partial destruction in the Civil War. It is a lovely corner of Warwickshire, but be prepared to wait to cross the bridge, which is narrow with traffic lights that are not the quickest. In 1922, a large Anglo-Saxon burial ground was discovered, with a wealth of bounty dating back to AD 500, including a collection of jewels, shields and artefacts.

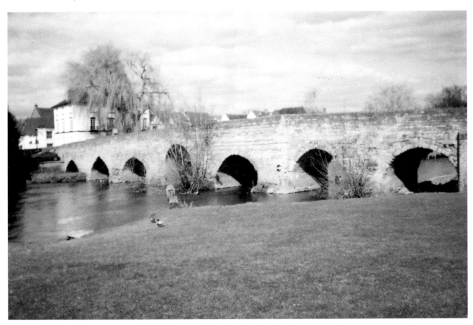

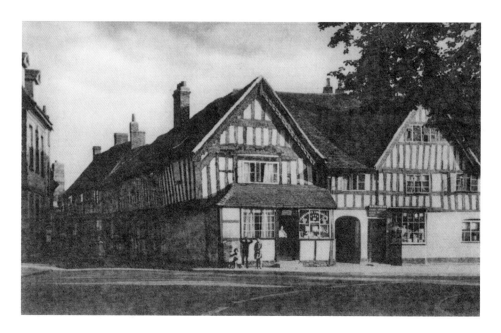

Malt Hill Lane, Alcester

Alcester is a town of the court leet. Of Roman origin, it stands at the junction of the Rivers Alne and Arrow. One of the finest streets of medieval timber-framed buildings in the county can be seen in Malt Mill Lane, where the houses have been restored to their former glory. When the summer months are upon us they are a pleasure to visit and a delight to see; its houses have gardens that have won a number of awards in the Britain in Bloom competition over the years. At one time, the houses were not considered fit to preserve. I, for one, am eternally grateful that they were not demolished, as they are a fine example of British architecture. Dominated by the parish church of St Nicholas, Alcester town centre has largely survived without being marred by multistorey car parks and large modern buildings.

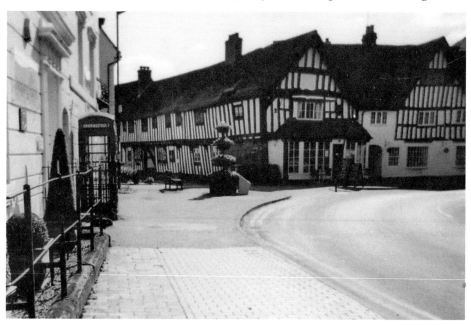

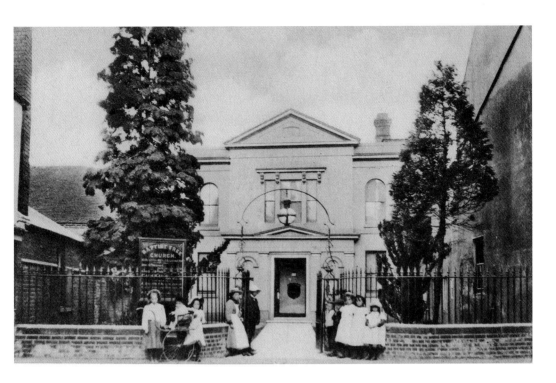

Baptist Free Church, Alcester

I love this charming photograph of the children dressed in their Sunday best, standing outside the Baptist Free Church in Alcester. As children, we had our Sunday clothes that were proudly worn for Sunday school and church with mother on a Sunday morning. This photograph was taken in the early 1900s, and the church would have taken an active part in these children's lives at this time.

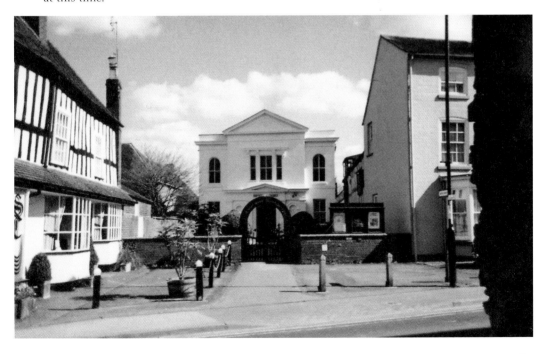

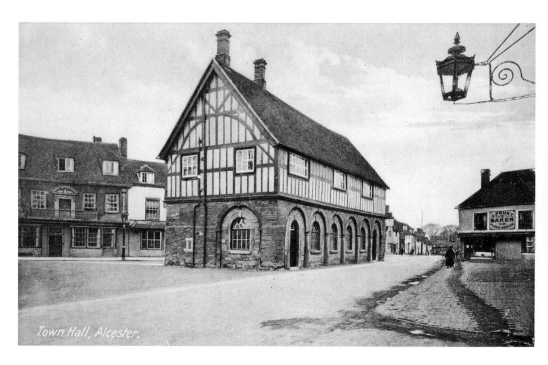

Town Hall, Alcester

Of Roman origin, the market town of Alcester has many seventeenth- and eighteenth-century houses still standing. The parish church of St Nicholas faces the High Street, and standing behind the church is the equally ancient Town Hall. Since early times Alcester has prospered and new residential estates have sprung up over the years.

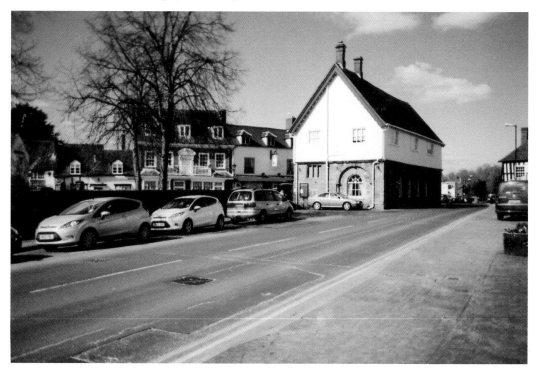

Wixford

According to the well-known jingle published during the festive season in the *Gentleman's Magazine*, Wixford was referred to as 'Papist Wixford'. The village lies across the valley of May Brook, and is a tributary of the River Arrow. The village is at the site of an ancient ford, which in 1566 was replaced by a bridge. In the churchyard there is an old yew tree, and legend has it that in 1669 the villagers sent a petition to the Bishop to prevent the local rector from chopping it down! Wixford has been in the parish of Exhall since the Reformation.

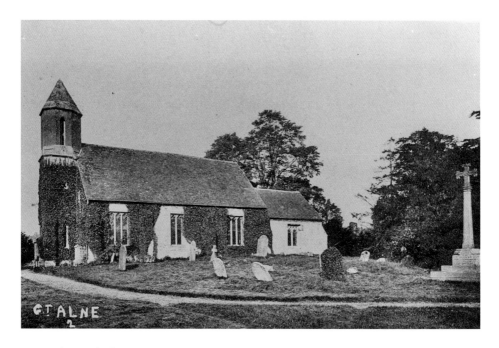

Great Alne and Kinwarton

Taken in 1908, this photograph provides a delightful insight into the village of Great Alne, with streets decked in bunting and the secluded village church. Although not marked on the map as such, Great Alne and Kinwarton are indissolubly joined. The River Alne skirts the two parishes on the south-eastern side and gives its name to the village of Great Alne. Mentioned in the Domesday survey, the river provided power for the Great Alne Mill, which was in business until the 1980s grinding wheat into flour.

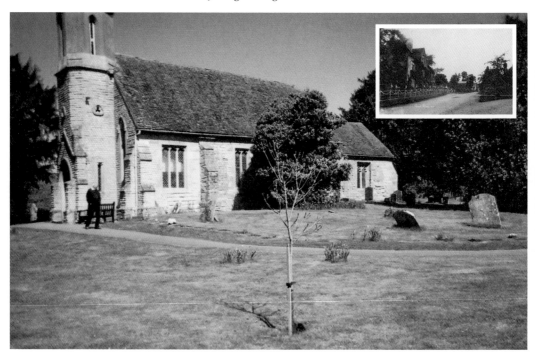

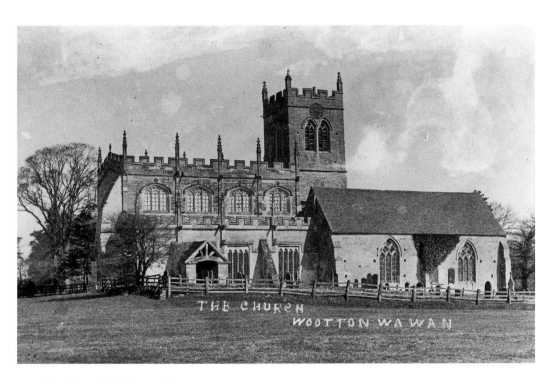

The Church, Wootton Wawen

One of the oldest settlements in the county is Wootton Wawen, which was founded in AD 723 in the reign of Ethelbald of Mercia. It was originally a Saxon 'farm by the wood'. The church at Wootton Wawen is one of the most interesting churches in the county, as it contains Anglo-Saxon work, in all probability paid for by Earl Weigen, which forms part of the substructure of the tower. The Saxon sanctuary stands beneath the tower and is used as a chapel. Near the entrance to the churchyard are the eighteenth-century lodge and gates.

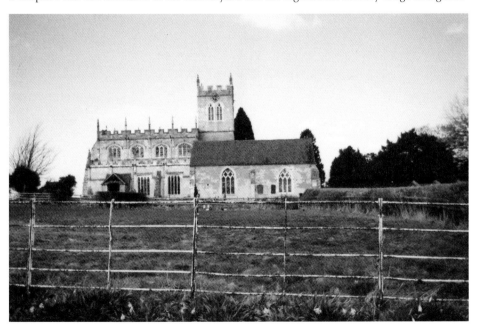

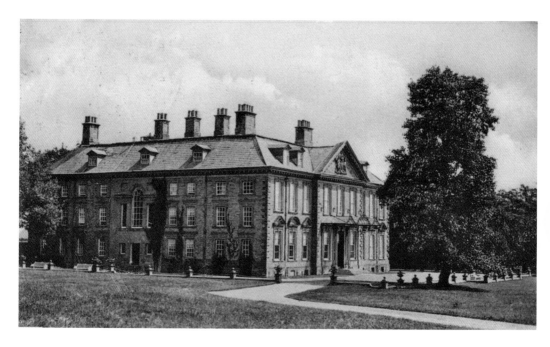

Wootton Wawen

At the turn of the century, Wootton Wawen was an agricultural village, with residents relying on farms and estates nearby for employment. The hurdle-making industry also employed a number of workers on the osier beds. The roads would have been very dusty in the summer months and muddy in winter, in contrast to the well-kept road surfaces of today. The Hall at Wootton Wawen still stands as grand as ever, but is now home to a very large and prestigious static caravan park in its grounds. It is reputed to be the most haunted building in the county.

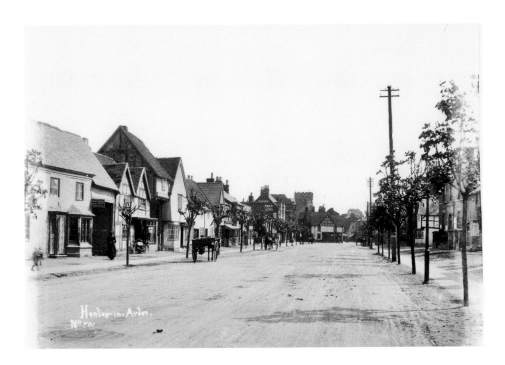

Henley-in-Arden

It has to be said that Henley-in-Arden is the finest example of an old market town in Warwickshire. The houses, most of them listed by the Department for the Environment, Food and Rural Affairs, date from the fifteenth century. The High Street is a mile long and has houses of almost every type of English architecture. The centre of the old Forest of Arden, Henley-in-Arden has a fifteenth-century church dedicated to St John the Baptist; its tower dominates the High Street. Henley is famous for its ice cream and tourists come from all over the world to taste it.

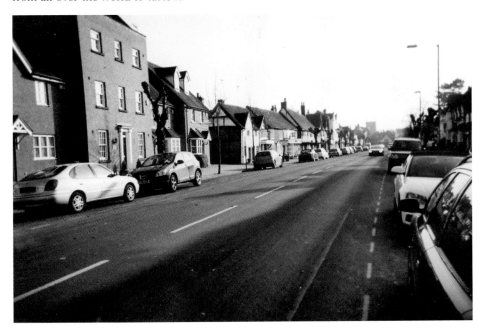

73

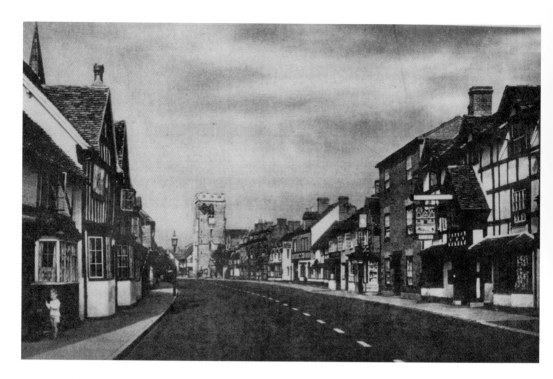

Henley-in-Arden

Henley-in-Arden was purchased by the American Joseph Hardy; contrary to the worries of the local folk, he spent money on the town. Thanks to his generosity, there is a heritage centre in the town, where an insight into history of the town and its inhabitants is on display. The main street in Henley-in-Arden is around 1 mile long. Although the town once sported a castle, this is sadly no more. In the centre of the village stands the fifteenth-century church of St John the Baptist, seen here in the centre of both pictures.

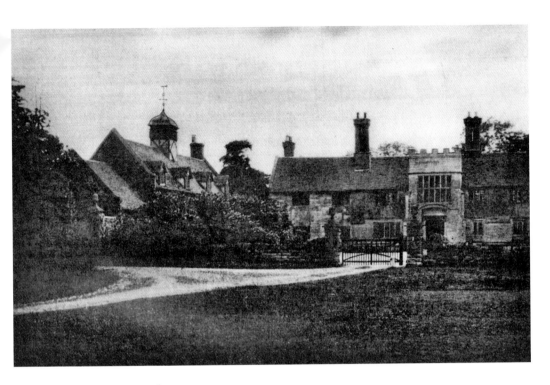

Baddesley Clinton Hall

Hidden from view, Baddesley Clinton Hall is accessible only along a right of way through a wooded park. It is considered to be one of the best surviving medieval semi-fortified manor houses in Warwickshire. It has a lovely old church nearby, and if you visit during the bluebell season, it is a sight to behold.

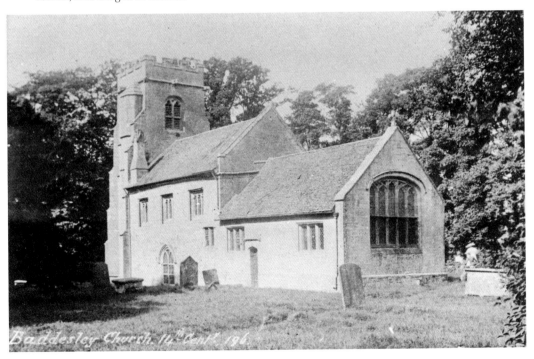

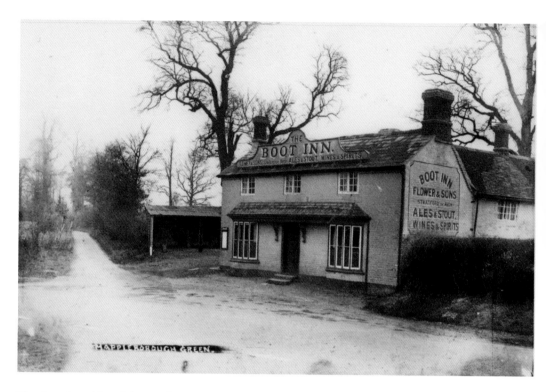

The Boot Inn, Mappleborough Green

Situated on the very edge of the county and looking towards Redditch, Worcestershire, is Mappleborough Green. The church of the Holy Ascension, built in 1888, is at the end of a group of buildings strung out alongside the main Birmingham Road. Here we see the Boot Inn, which was run by the Flowers & Sons Brewers of Stratford upon Avon, but is now a free house.

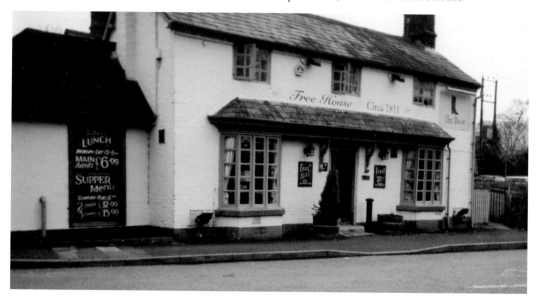

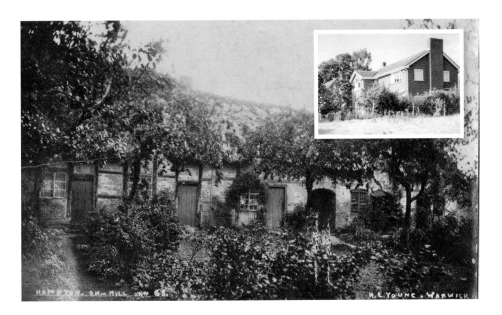

Hampton on the Hill

As the name suggests, Hampton stands on a hill, which affords panoramic views of the surrounding area, in particular of neighbouring Warwick and its famous racecourse. These beautiful old cottages stood at the top of the hill at Hampton, opposite what was Pettles Farm in the 1800s. It is a rare postcard view. Modern detached houses (*inset*) now stand on the old site. In the centre of the village stands the Roman Catholic church of St Charles of Borromeo, named after an archbishop from Milan. Inside the church is a statue of Mary wearing a cross and chain, thought to be the only one in England. Below, a colourful character resident in Hampton on the Hill in the early twentieth century, Mr Sidney Hiatt, photographed in St Luke's Road in Coventry. Mr Hiatt worked as a gardener for a Mr Day. A man of many talents, Sidney also drove a funeral hearse. The watering can was a must-have in years gone by.

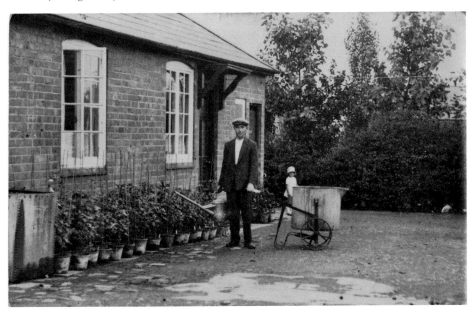

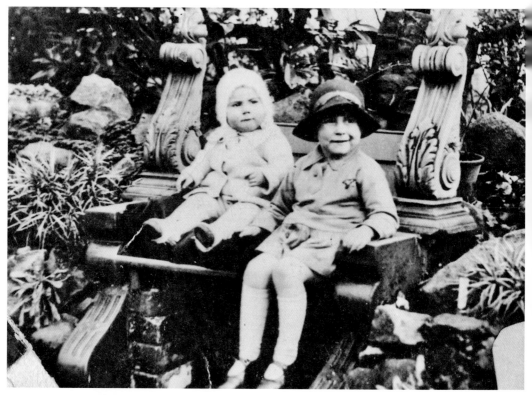

Alice

This lovely lady, Alice Hiatt, was born in Hampton on the Hill, and we follow her through time. In the top picture we see Alice with her sister Beryl. Sadly, Beryl was to pass away very young with leukaemia. Seen in uniform, Alice was later in the Red Cross 44th Warwick detachment, and we see her with her husband, Mr Scott (*inset*). They now live in Royal Leamington Spa.

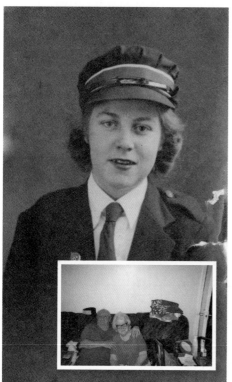

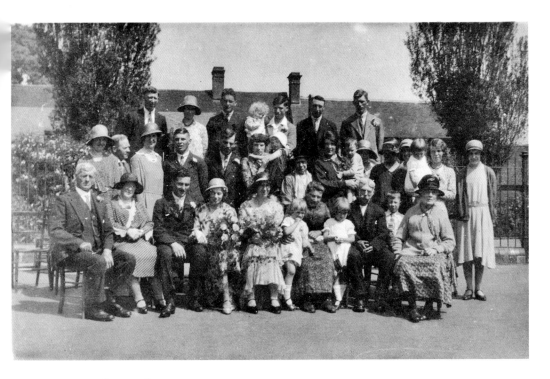

Hampton Village Folk

People are the heart of the community and contribute greatly towards the history of the place they live in. Here we see two photographs of the people of Hampton on the Hill enjoying life. The top picture shows Florie Higgerson's wedding party, photographed outside Budbrooke church in 1930. The other photograph shows the village elders about to join the vicar on an outing. At a time when motor cars were a luxury, the day's outing was a treat indeed.

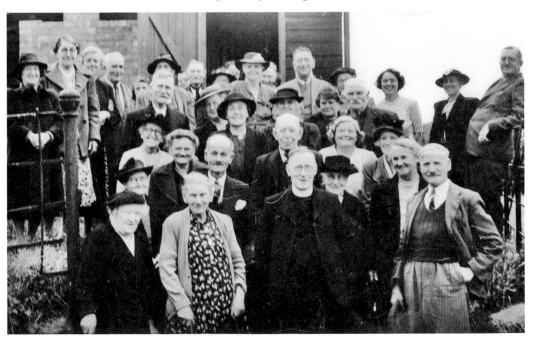

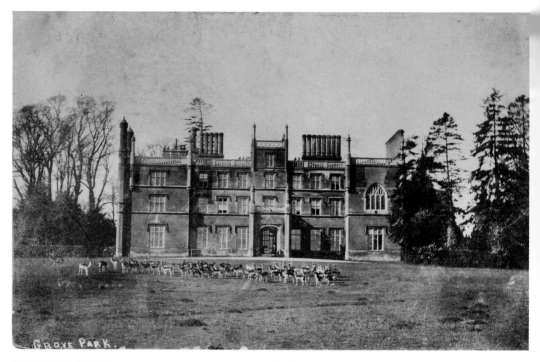

GROVE PARK.

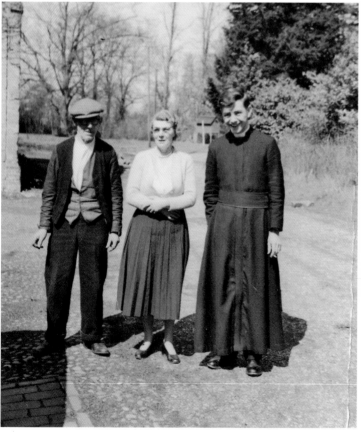

**Grove Park,
Hampton on the Hill**
This beautiful country
house and the large
park that used to be
there, seen here in the
late 1800s, was the
home of the Dormers.
The house was turned
into a hospital for
returning troops and
the walking wounded
during the World
Wars. Afterwards, the
house became the
venue for a seminar
for training young
Irish priests. It was to
become a conference
centre before meeting
its demise. The
photograph to the left,
taken in 1962, shows
Mr Hiatt, who was
the gardener, with his
wife and one of the
young trainee priests.

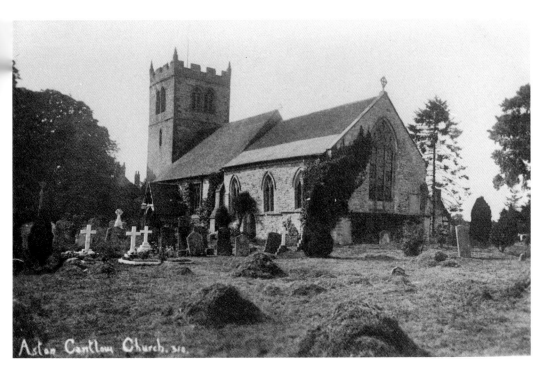

St John the Baptist Church, Aston Cantlow

The church of St John the Baptist, parts of which date back to the thirteenth century, has many claims to fame. William Shakespeare's parents are said to have been married in the church and their first child was baptised here in 1558. There is a fine medieval guildhall that stands opposite the Kings Head public house. Part of this guildhall used to be the village jail. The building, which was first recorded in 1442, is now used as the village hall.

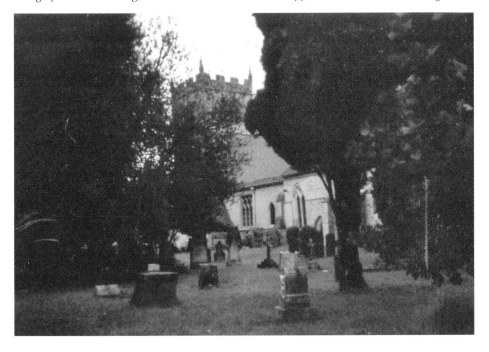

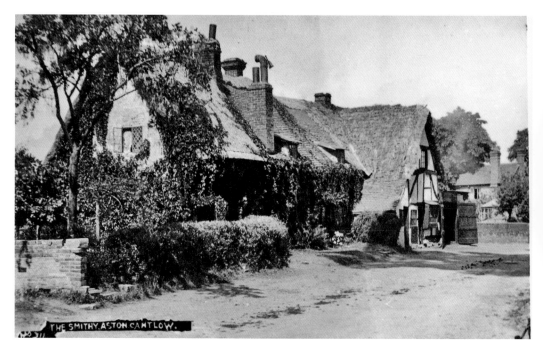

Aston Cantlow

I have very happy memories of Aston Cantlow at the Kings Head Inn, with their famous duck suppers. These were very popular and had to be booked well in advance, as people came from all over the county to enjoy them. Standing opposite the Kings Head Inn is the guildhall, which is believed to have been the home of the Guild of St Mary in 1442. Originally, the village was built near a ford over the River Alne, which floods after heavy rain, making approach roads impassable. The parish church of St John the Baptist is reputed to be the place where William Shakespeare and Mary Arden were married in 1557. Agnes, Mary's sister, was buried here in 1596.

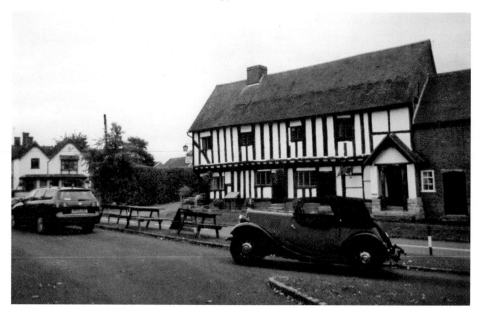

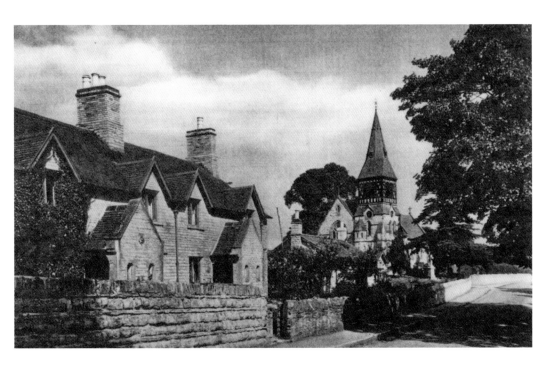

Temple Grafton

Here we see the church of St Andrew, Temple Grafton, which was rebuilt in 1875 on the site of the original Saxon church. Legend has it that this was the church where William Shakespeare married, but there is no proof to support this claim. The village is known as 'Hungry Grafton', which referred to the land and not the people! Its cottages are built of stone and brick, some with thatched roofs, while others had exposed timber framing.

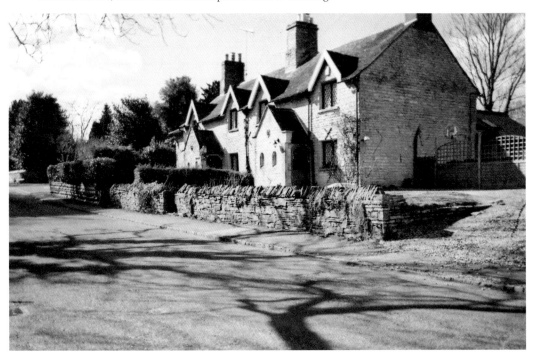

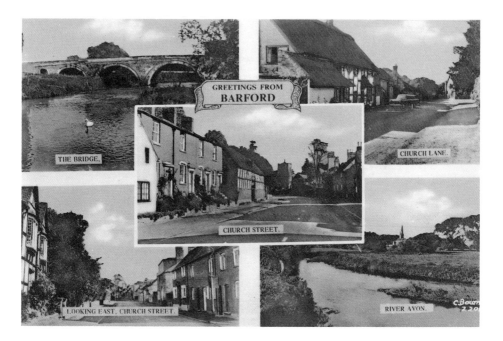

Barford

Here we see some delightful pictures of Barford, better known as the home of Joseph Arch, who was born in a tiny cottage opposite the parish church in 1826. He was an agricultural worker who was instrumental in organising a protest meeting against the poor wages agricultural workers received for their labours, which took place in the neighbouring village of Wellesbourne. The meeting was held on 7 February 1872 and resulted in the formation of a trade union for the farm workers of Warwickshire. It was later to become the National Agricultural Labourers' Union. Arch was to go on to become a Liberal MP. Seen in the bottom postcard is a fine example of an eighteenth-century stone bridge. It carries the Warwick to Wellesbourne road over the River Avon at the site of an earlier ford.

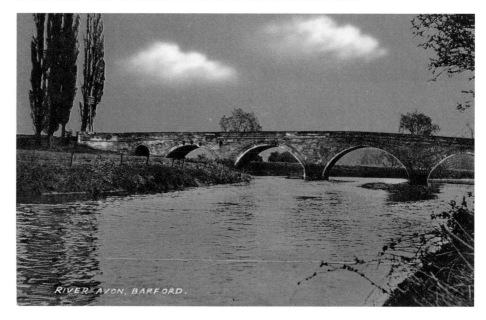

Maxstoke

What strikes you about Maxstoke are its timber-framed brick houses and old cottages, which are two or three hundred years old. The fourteenth-century church of St Michael and All Angels has a wooden bell turret within the west end of the nave. The castle was built by Sir William de Clinton and is still surrounded by its moat. Although it was never a castle as such, being more a fortified manor house, it is undoubtedly one of the finest examples of its type in Warwickshire.

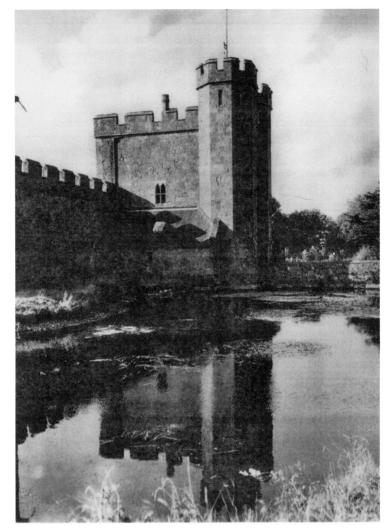

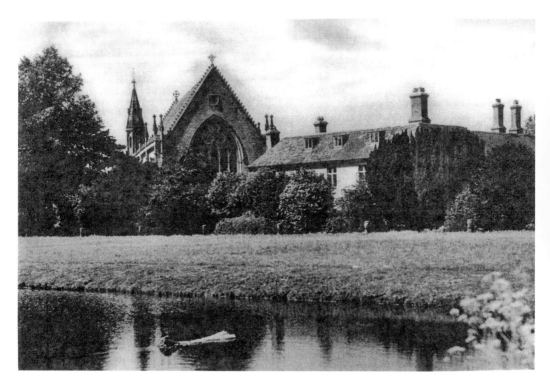

Temple Balsall

One of the best examples of late thirteenth-century architecture to be found in the Midlands is the parish church of St Mary at Temple Balsall, which first became a parish church in 1863. In the top photograph, we see the exterior of this lovely old church in all its glory, while in the bottom postcard we can see inside the interior of this delightful building.

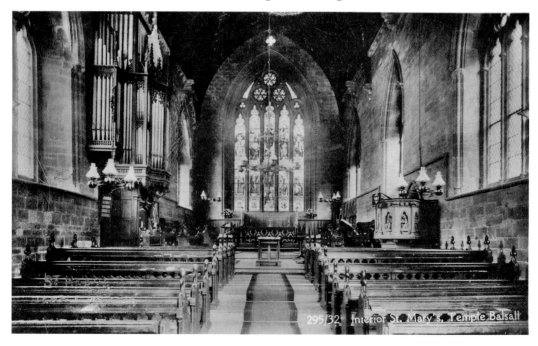

295/32 Interior St. Mary's, Temple Balsall

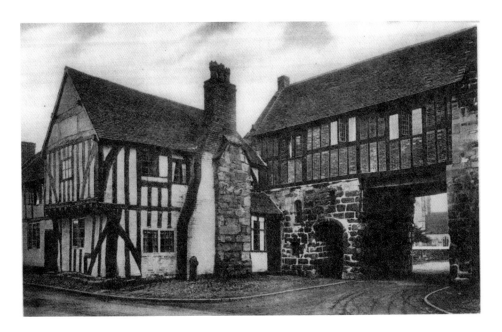

Polesworth

Bordering Staffordshire and Leicestershire at the tip of North Warwickshire lays the large Saxon village of Polesworth. To reach the village, which has two railways, the River Anker and three canals, one has to cross a bridge. The photograph shows the Nunnery Gateway that is the entrance to the church. It is one of the oldest buildings in the county. Being the county's most ancient community, it was already a flourishing settlement by the River Anker when King Egbert founded the Benedictine abbey. The first abbess was his daughter Editha, to whom the parish church is dedicated. The town had teaching nuns among its residents long ago, who taught needlework to the girls of the village. Polesworth was also one of the first villages to have electricity.

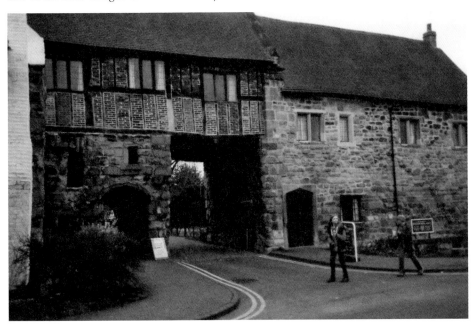

Atherstone Church

In the north of the county is Atherstone, which lies 200 miles from London. The main street through the town is Long Street, which is over a mile long. Many of the buildings date from the sixteenth century onwards. In early times, Atherstone was the centre of the hat-making industry. The church of St Mary stands at the end of a square off the main street.

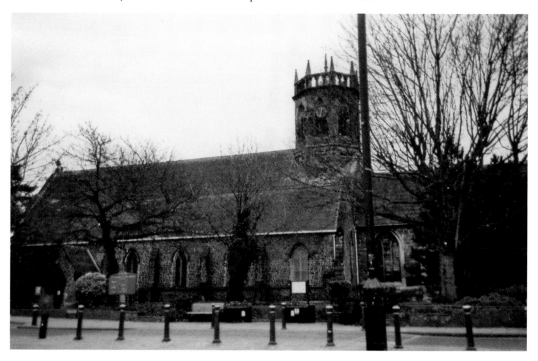

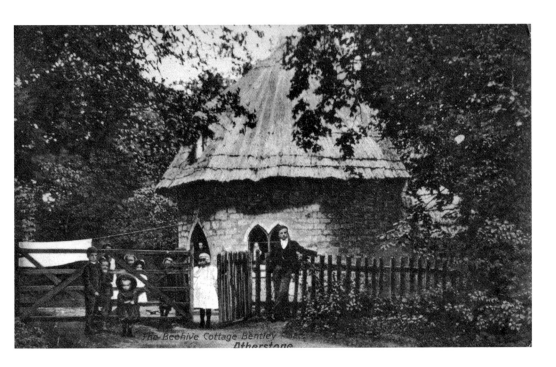

The Beehive Cottage Bentley Road Atherstone

Atherstone

Lying around 200 miles from London, Atherstone stands in North Warwickshire, straddling Roman Watling Street and the present-day A5. The old Roman section of the town is the mile-long main thoroughfare, aptly referred to as Long Street. Thanks to the bypass pedestrians can now use Long Street in relative safety except for Shrove Tuesday, when the Atherstone ball game, a bizarre tradition dating back to medieval times, takes place every year. The historic parish church of St Mary stands in the heart of the town and makes an impressive sight with its Gothic-style tower.

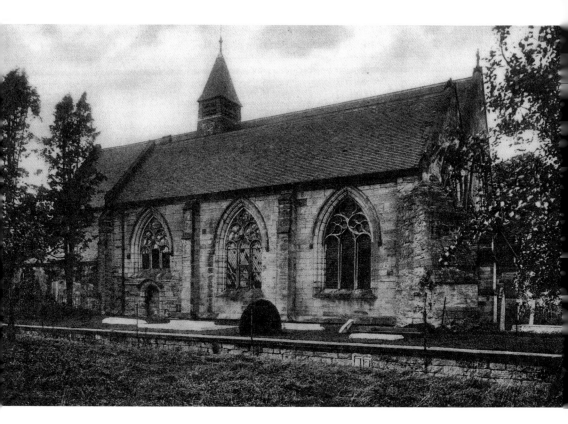

The Church of Merevale Abbey

An impressive-looking Victorian medieval gatehouse leads to Merevale church and hall, situated by the road from Baxterley to Watling Street. The parish church of Our Lady dates from around the twelfth century, but the Cistercian abbey founded in 1148 only survived until the dissolution of the monasteries by Henry VIII.

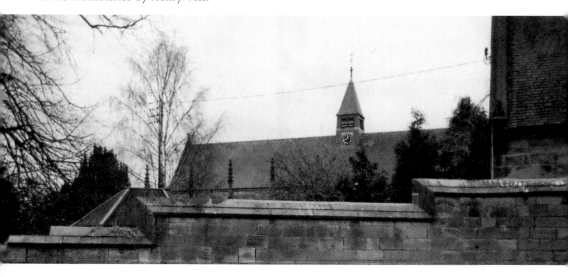

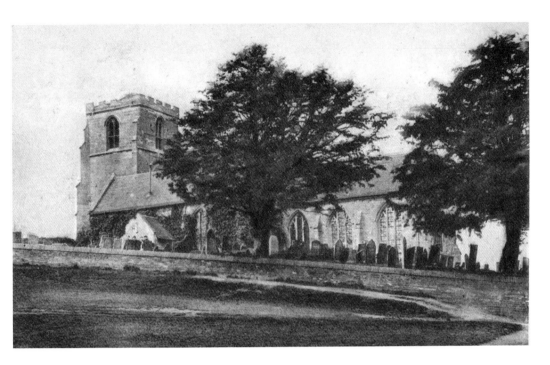

Mancetter Parish Church

The countryside around Mancetter was once part of the Arden Forest, with five farms in the area. This is no more and the village now has a housing estate, large recreational ground and a golf course. There is also limited access to the Bluebell Woods and a reservoir. The two quarries have now closed and there is no longer mining carried out in the area. Here we see the church, the construction of which was started by Guy de Mancestre in the fourteenth century. He passed away in 1365, before it was finally completed in the fifteenth century.

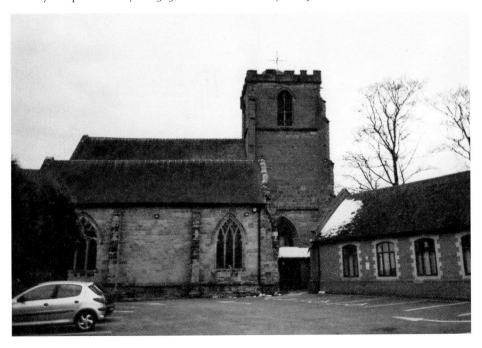

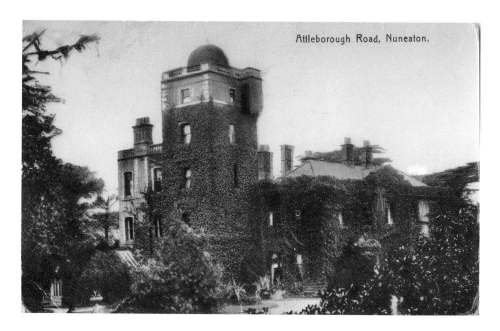

Attleborough Road, Nuneaton.

Nuneaton

Nuneaton stands on the edge of a coalfield at the north-east corner of Warwickshire and at the time of the Domesday survey was a small hamlet. The famous author Mary Ann Evans, better known as George Eliot, was born in 1819 at South Farm, Arbury. Like all old towns, Nuneaton has spread out over the years, and south of the River Anker is the urbanised village of Attleborough. Many of the books George Eliot wrote used thinly disguised locations in and around Nuneaton, and in recognition the local hospital has been named after her, with many of the wards taking the names of characters in her books. Below, we see Attleborough Road.

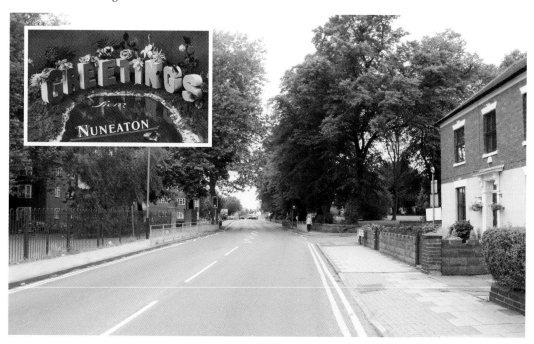

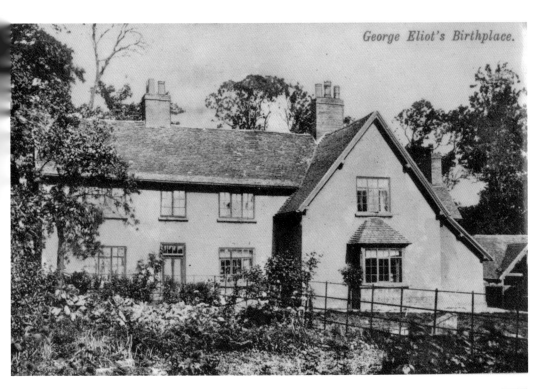

Arbury

Here we see South Farm, Arbury, the birthplace of Mary Ann Evans in 1819. Mary Ann was better known as George Eliot. Her father was agent to Mr Francis Parker Newdigate of Arbury Hall, on whose estate he farmed.

George Eliot

SPEIGHT·NUNEATON. 1.

"THE MILL ON THE FLOSS" MUST ALWAYS BE VERY INTERESTING TO ALL WHO KNEW GEORGE ELIOT AND LOVED HER WORK, IF FOR NO OTHER REASON, FOR ITS AUTOBIOGRAPHIC AND PERSONAL TOUCHES · · AND ITS REVELATION OF YEARNINGS AND MISGIVINGS HARDLY SUSPECTED IN LIFE "

FREDERIC HARRISON. STUDIES IN "EARLY VICTORIAN LITERATURE".

Down Birmingham

The railway network weaves its way through Warwickshire, and here we see 'Down Birmingham', one of the fleet of high-speed express trains between London Euston and Birmingham. The bottom postcard shows an LMS Stanier, travelling to Coventry, Rugby, Market Harborough and beyond. The shire lays claim to one of the longest cuttings in the world, Harbury Cutting north of Fenny Compton on the Great Western Line. In 1876 it suffered a landslide that resulted in the line being closed for several months.

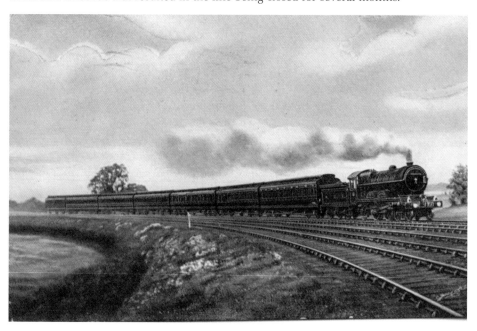

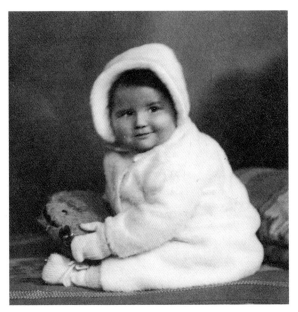

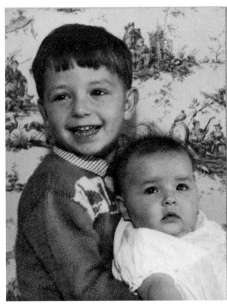

A Warwickshire Family Through Time

It is always a privilege for me to include a family photograph, and here we see a delightful photograph of Warwick-born Margaret Garrison, taken in 1939. Many years later we see the baby all grown up (*right*) and visiting Navy Day at Plymouth in 1955. Margaret was to become Mrs Norman Guerney, and they had two lovely children. In the top right picture see the children, Steven and Lyn, in 1964. Sadly, Steven was killed in an accident in 1980.

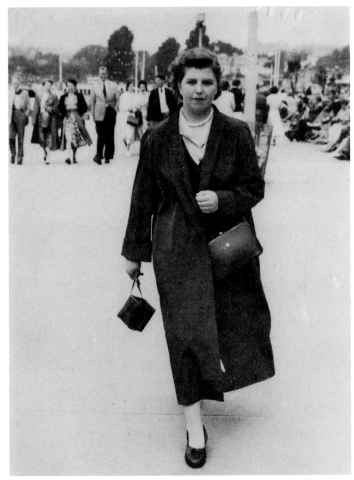

Atherstone Through Time
Christine Freeman

This fascinating selection of photographs traces some of the many ways in which Atherstone has changed and developed over the last century.

978 1 4456 0714 6

96 pages, full colour

Available from all good bookshops or order direct
from our website www.amberleybooks.com